MW00813593

Dearest Lucille,
I saw this book and
immediately thought of you!
Happy Birthday!
love,
Marisa
'19

IMAGES
of America

OCEAN BEACH
WHERE LAND AND WATER MEET

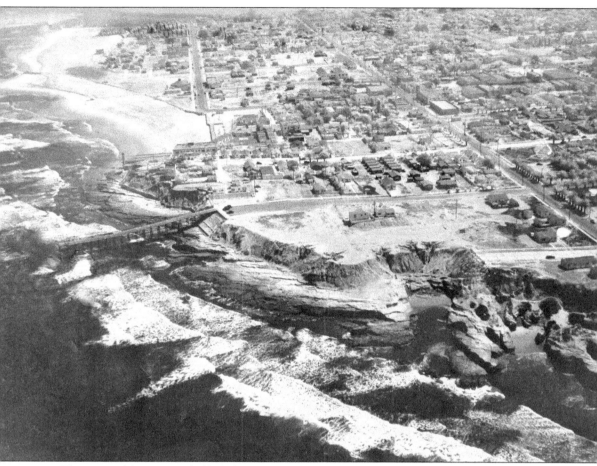

This view of Ocean Beach (OB) shows sand where some of the original coastal buildings stood; they were removed by 1942 because of storm damage. Quite a few open lots and small dunes had existed to the north. South of the Del Monte Avenue pier, the natural cliffs' beauty was seen in the rock formations, caves, and sandy coves. (Courtesy the Ocean Beach Historical Society.)

ON THE COVER: Three finely dressed women in heels stand on the rocks as they add some silliness to their pose at the Ocean Beach Cliffs in front of Abalone Cove, near the staircase that leads up to Del Monte Avenue and the trolley stop. (Courtesy the Ocean Beach Historical Society.)

IMAGES
of America

OCEAN BEACH
WHERE LAND AND
WATER MEET

Kathy Blavatt
Foreword by Eric DuVall

ARCADIA
PUBLISHING

Published by Arcadia Publishing
Charleston, South Carolina

Library of Congress Control Number: 2017952296

For all general information, please contact Arcadia Publishing:
Telephone 843-853-2070
Fax 843-853-0044
E-mail sales@arcadiapublishing.com
For customer service and orders:
Toll-Free 1-888-313-2665

Visit us on the Internet at www.arcadiapublishing.com

This book is dedicated to William "Willie" Johnson and his wonderful smile. Willie is described in the OB Rag as being "the Honorary Mayor of Ocean Beach" and the face of Newport Avenue to his many friends and the merchants. Willie is a man who will always be a part of Ocean Beach's history.

CONTENTS

Foreword 6

Acknowledgments 7

Introduction 8

1. On the Water's Edge of Ocean Beach 9

2. Historic Homes and Cottages 25

3. At the Beach 39

4. Main Street Mom-and-Pop Shops 59

5. The Greening of Ocean Beach 83

6. Local Color 103

7. The Children of Ocean Beach 117

FOREWORD

Head west in the continental United States, and Ocean Beach, California, is as far as you can go. OB, as it is lovingly referred to, is the western terminus of the Interstate 8 freeway. Ocean Beach is also where the San Diego River flows into the Pacific Ocean. The wide sandy beach the river created and the vastness of the Pacific Ocean beyond it have symbiotically helped to shape the singular nature and unique (counter)culture of the community, as Kathy Blavatt describes in chapter 5. Brooks Barnes observes in the September 4, 2008, *New York Times,* "There are dozens of beaches, but none more authentic than Ocean Beach, a funky surfers' haven that has stayed frozen in time because of strict zoning rules from the 1970s . . . you might feel conspicuous without a surfboard or bare feet." Indeed, "OBceans" have worked hard over the decades to preserve the beach town flavor of this charming community.

A historic preservation district was established to help Ocean Beach cottage owners keep and rehab their older homes. Local activists have worked for decades and, with some success, to keep large chain stores out of Ocean Beach. Local family retailers and mom-and-pop shops have been the beneficiaries.

The 1960s and 1970s, a time of turmoil in the United States, was also a time of grassroots community organization and bonding in Ocean Beach. The area has always been a mecca for freethinkers and nonconformists, and OB's activists, business community, young people, and radicals have come together again and again to save her public parks and beaches and to ward off unwanted megadevelopment.

Over the years, Ocean Beach's colorful characters, pioneers, community leaders, and children have made up the fabric of the community. These personalities come to life throughout this book.

—Eric DuVall, coauthor of Arcadia Publishing's *Point Loma* and
president of the Ocean Beach Historical Society

ACKNOWLEDGMENTS

Ocean Beach has vibrant ongoing history that thankfully the Ocean Beach Historical Society (OBHS) and its dedicated volunteers help preserve through their extensive archives, programs, and events. The OBHS assistance and photography collection was vital in the production of *Ocean Beach: Where Land and Water Meet*. Unless otherwise noted, all images are courtesy of the Ocean Beach Historical Society.

Additional background and production materials, collections, and photographs came from many individuals, families, and organizations—some still here and others we remember who help preserve and make Ocean Beach's history.

In appreciation to the preservation of history, I applaud Stephen Rowell for his marvelous photographs, Tom and Jane Gawronski for their community advocacy and cottages preservation efforts, Newport Avenue's Willie Johnson for his collection, John Aryes's historical photograph collection, and Jane Meiners's beautiful photographs.

Great gratitude goes to the founding families' historical collections, which include Vince Adame for the gift of sharing the McElwee/Peace legacy and incredible photographs, the Clarkes' Wisteria Cottage and other photographs, the Mehling family's decades of images, Willamartha Aiken fashion shots, the Fabers' market photographs, and the Beardsleys' collection. Appreciation also goes to the Masseys for the joyful children photographs, the Petersons' bakery shots, and both the Davis and Bille families for their records of West Point Loma Avenue. Fond memories will always be held of *Hot Curl* cartoonist Mike Dormer. Thanks go to the OBceans that care, such as Colleen Dietzel for her heart of "green"; People's Food Co-op, for our historic organic food co-op; Mignon Scherer and Alex Leondis, for the gift of the coastal 30-foot height limit law; Robert Burns, for his work in saving the Red House; and the *OB Rag*, for a wealth of historical background.

As for past Ocean Beach historians, enormous gratitude goes to Ruth Held, Carol Bowers, Ned Tilow, and others.

My appreciation also goes to Caroline Anderson of Arcadia Publishing for her help and guidance.

INTRODUCTION

Ocean Beach is a giant playground where generations of children splashed in the surf, explored tide pools, played in yards, fished, ate ice cream, biked, and enjoyed countless wonderful activities.

I had an extraordinary childhood living by the beach. My surfer father built his oceanfront dream home on Sunset Cliffs Boulevard in 1967. In 2004, my husband and I purchased an Ocean Beach house with an ocean view.

My connection and love for the peninsula was reinforced when I found a couple of 1924 photographs of my grandmother that showed her at age 14, sitting at Spalding's Sunset Cliffs Park with her sister and friends, and another of a Dodge touring car in Ocean Beach, with three generations of my female relatives. I have been a local history buff since seeing those wonderful pictures.

Ocean Beach comprises of one square mile of landmass that borders on the Pacific Ocean, the San Diego River, and Mission Bay (originally False Bay), former tidal wetlands. These bodies of water continually reshape the land through weather conditions.

Ocean Beach, formerly Mussel Beds, was renamed in 1887 by founders William "Billy" Carlson and Frank Huggins, real estate peddlers who would entice early settlers to buy lots by staging elaborate promotional events and showing off the area's natural beauty. A second wave of arrivals flooded in with the opening of the Wonderland Amusement Park in 1913.

Ironically, Ocean Beach remains one of the last small beach towns because founder (and greedy) Carlson subdivided lots into smaller parcels, which caused smaller homes to be built in the styles of quaint beach bungalows, Craftsman cottages, and Spanish Mission cottages.

Hearty settlers and creative visionaries with skills and talents built the unique community. In later years, these spirited characters were given the title "OBceans."

Main Street's mom-and-pop businesses, churches, organizations, schools, the library, the recreation center, and annual events formed the foundation for the community. Local residents include champion swimmers, surfers, and athletes. Renowned creative talents include artists, musicians, and writers. Ocean Beach has led in horticulture, environmentalism, and the activist movement.

One

ON THE WATER'S EDGE
OF OCEAN BEACH

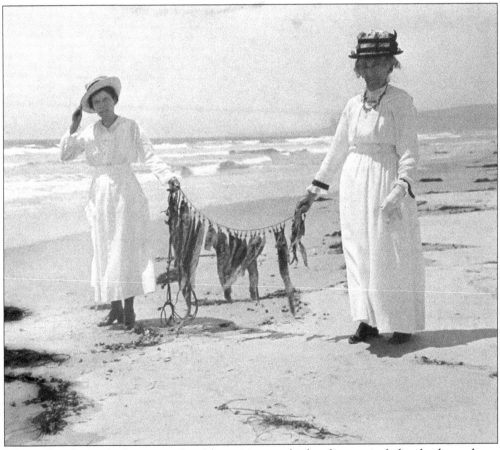

Glorious beaches with white-capped surf drew visitors to this beach town, including land speculators and founders Billy Carlson and Frank Huggins, who changed the name Mussel Beds to Ocean Beach in order to sell lots in 1887. Their early promotion "Ocean Beach is the Garden of Eden" brought many folks to the little San Diego beach town. These two women pose for a great photograph on a long stretch of sun-drenched sand with whitecap waves. They use giant bladder kelp found on the beach as a prop. Ocean Beach's sandy shores were not the only beach attraction. The southern cliffs were also a draw, with breathtaking views, glorious sunsets, and caves to explore. The scenic cliff locations had fanciful names such as Abalone Cove, Cleopatra's Needle, Alligator Rock, Crawfish Cove, and Rocky Point. (Courtesy the Ocean Beach Historical Society.)

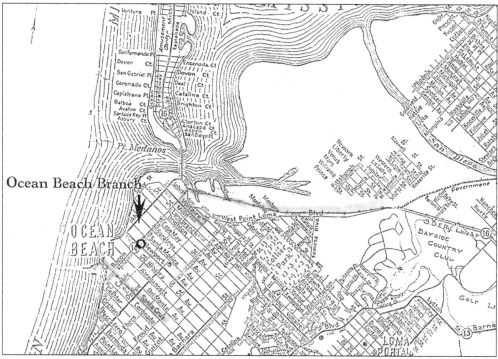

This late-1920s map shows the San Diego Electric Rail lines that ran from Old Town to North Ocean Beach. From 1915 through 1951, the Mission Beach Bridge went from Mission Beach, over False Bay, to Bacon Street in Ocean Beach. The bridge had a trolley line, two car lanes, and sidewalks and was a popular fishing spot. This map also shows the streets, the shoreline, and the Collier Park site.

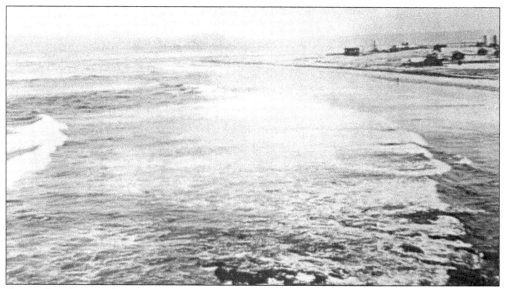

Ocean Beach's population was sparse in the early 1900s, with mostly beach shacks, as seen in the foreground on the sand and Cape May Avenue. A few of these cottages still stand today, and some are designated as part of the Ocean Beach Historical Cottage Program. (Courtesy Robert Burns.)

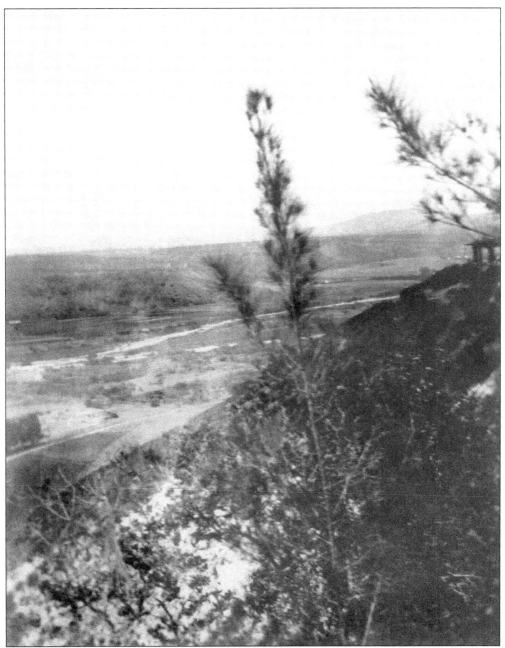

This hillside view photograph was taken on July 13, 1920. It overlooked the sparsely populated farmland in Mission Valley and the San Diego River that flows west into False Bay and the Pacific Ocean in Ocean Beach. The view four years earlier in 1916 was quite different. The largest storm of the century caused tremendous flood damage to farms and the floodplain from the storm water runoff from the surrounding hillsides. Downriver structures were badly damaged, including the base of the Ocean Beach Wonderland amusement park roller coaster and the train tracks. The well-built San Diego Electric Rail Mission Bay Bridge that connected Ocean Beach to Mission Beach was one of the few San Diego bridges that had little damage and was left standing after the tremendous storms. (Courtesy Mehling family.)

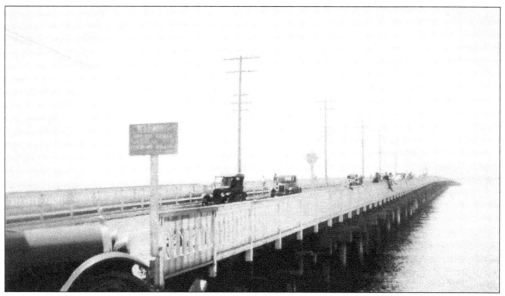

To encourage development and commerce in 1915, John D. Spreckels and his Bayshore Railway Company built the 1,500-foot wooden Mission Beach Bridge over False Bay. The bridge spanned from Mission Beach to Ocean Beach, and then the streetcar tracks continued to Old Town and on to Downtown San Diego.

The Mission Bay Bridge in the 1940s offers a welcoming view of Ocean Beach's silhouetted palm trees. At the foot of the Ocean Beach side of the bridge is Ray's Cafe (left), a burger shack owned by the Prather family. The bridge was removed in 1952. Fill was put in this section of bay for the future Robb Field Park.

The Ocean Beach Dance Pavilion and Beach Club along the beach at the foot Newport Avenue was hit by decades of storms, large waves, and high tides. This caused damage over the years, as seen here in 1926. The large building was removed in 1942, and the site became a parking lot.

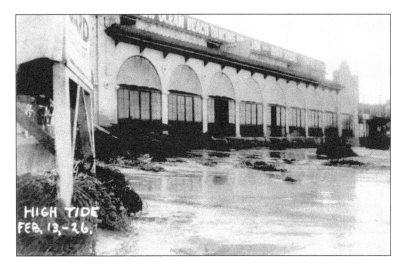

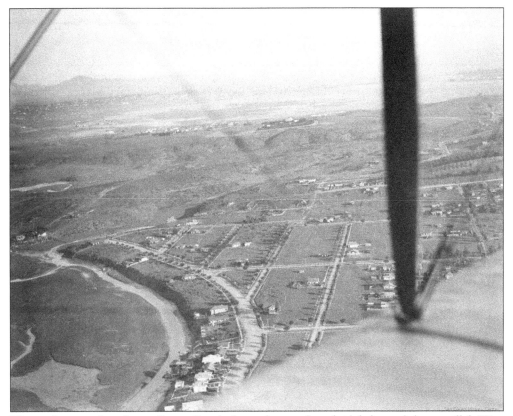

This early view of northeast Ocean Beach shows the marsh and tidal channel that parallels West Point Loma Boulevard then turns right into Harold Canyon (now Nimitz Boulevard). Just above the channel is a spattering of homes, with detached boathouses facing the marsh. West Point Loma Boulevard and main streets are lined with Monterey cypress saplings and other trees due to David Charles "D.C." Colliers's beautification vision. (Courtesy San Diego History Center.)

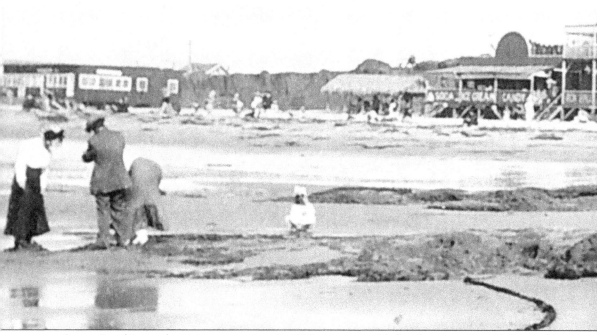

Ocean Beach's popular visitor attractions in 1917 were accessible by electric trolleys. Folks could dine on the beach at Budd's Fish House and eat local mussels, clams, fish, or eat treats or ice

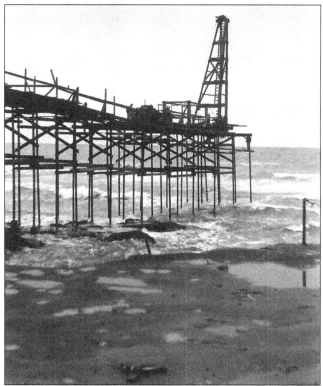

Construction of the Ocean Beach Pier at the foot of Del Monte Avenue began in 1914. Work was stopped shortly after World War I due to scarcity of labor and materials. Later, the construction restarted with steel railroad rails salvaged from the street railway overhead near the Marine base. (Courtesy McElwee/Peace family.)

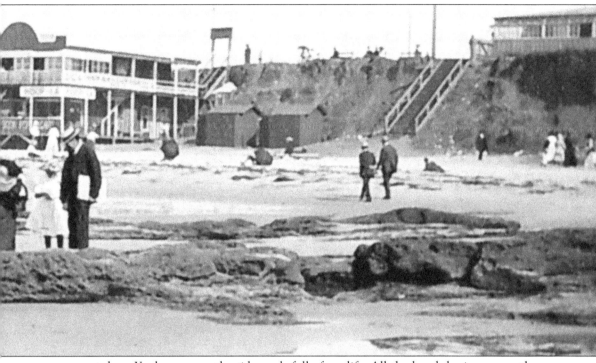

cream next door. Yards away are the tide pools full of sea life. All the beach businesses on the sand below the cliff are long gone. (Courtesy McElwee/Peace family.)

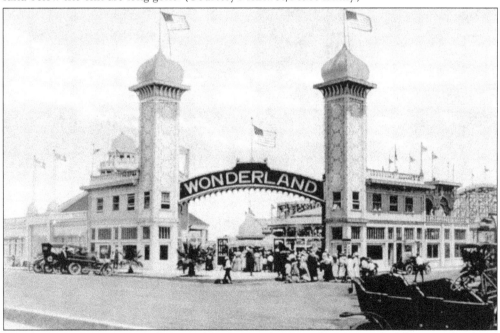

Wonderland Amusement Park located at the northwest end of Ocean Beach opened to huge crowds in 1913. By 1915, Wonderland's attendance and profits were down, mainly because of the competing Panama-California Exposition at Balboa Park. Storm damage in 1916 washed away the sand under the roller coaster, and Wonderland was on its way out.

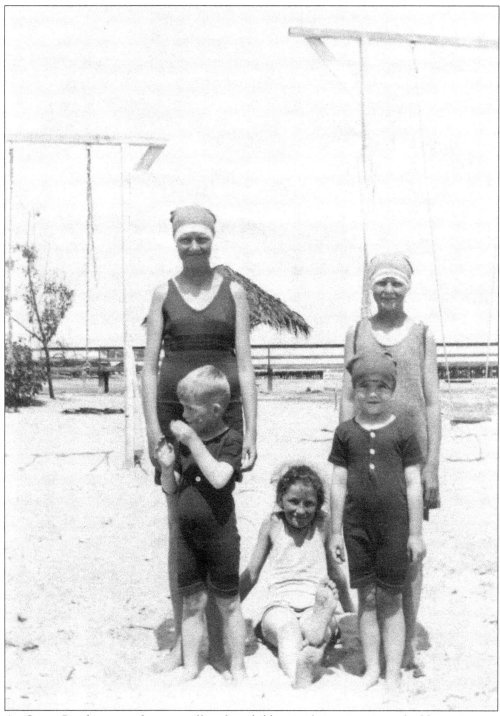

An Ocean Beach mom and a group of barefoot children in their swimsuits and rubber swim caps enjoy their day at the beach in the 1920s. The kids on the sand are in front of the Ocean Beach playground, where there were two swing sets and a slide to play on.

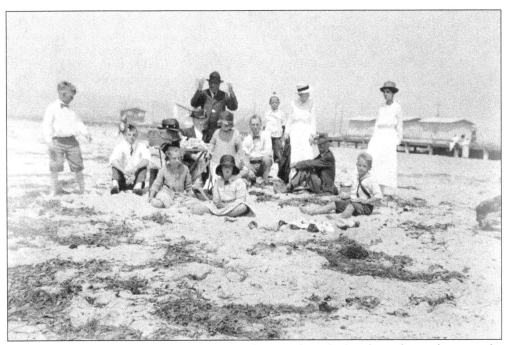

This dapper group poses for an Ocean Beach photograph at the beach on the sand, among the dried kelp, in front of a few raised buildings. The women wear their cotton dresses and hats, while the men and boys wear their dress clothes, sporting white shirts and ties.

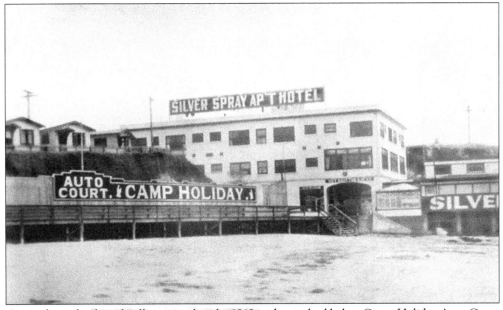

A raised wooden boardwalk was in place by 1919 and stretched below Camp Holiday Auto Court and its large sign over to the Silver Spray Apartments and Hotel and onward to the Silver Spray Plunge. The boardwalk also connected to the staircase leading to the beach and the tide pools.

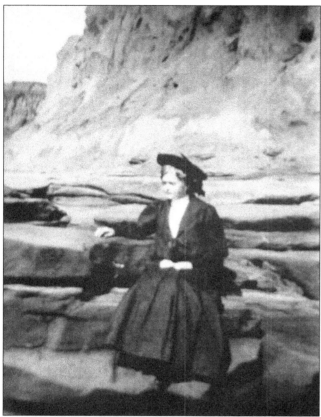

Helen Bieweuer poses for her photograph at the beautiful Ocean Beach cliffs. Visitors had access to the cliffs and coves from the northern tide pools by the Silver Spray Plunge, the Del Monte Avenue staircase by the visitor pavilion and nearby trolley stop, or at Santa Cruz Avenue above Crawfish Cove.

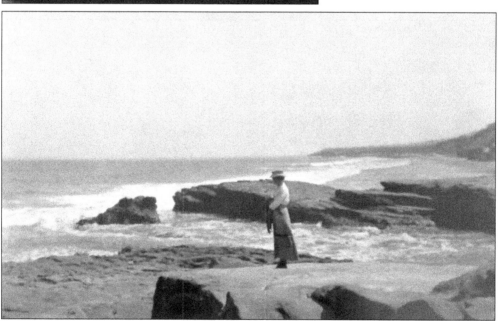

This woman stands on the cliffs at Spalding's Sunset Cliffs Park in 1918. Long lines of surf and Ocean Beach's cliffs are seen to the south. This photograph of the cliffs was taken below where the first parking lot on Sunset Cliffs Boulevard is today.

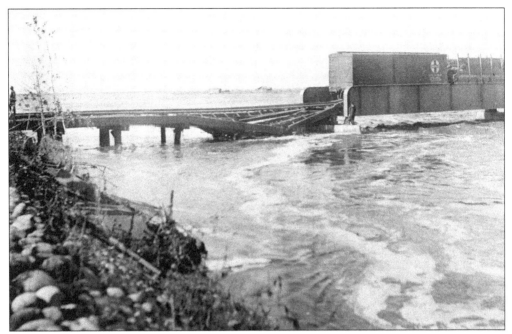

The 1916 "storm of the century," which was attributed to Charles M. Hatfield, "the rainmaker," caused much damaged to the trains and tracks going to Ocean Beach. The storm and torrents of water destroyed many bridges and caused millions of dollars in damage throughout San Diego.

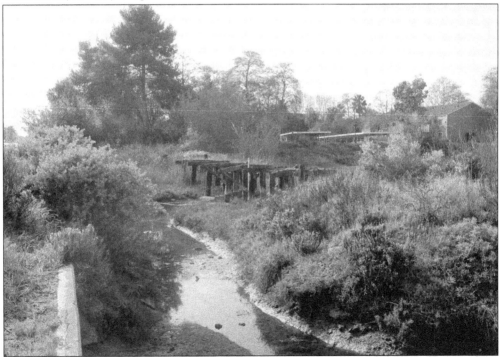

The supports of a wooden bridge from the old Ocean Beach train connection can be seen to the north of Point Loma Avenue in the Famosa Slough channel. This is the last remnant of the old train line. Natural decay is eating away at this bit of history. (Author's collection.)

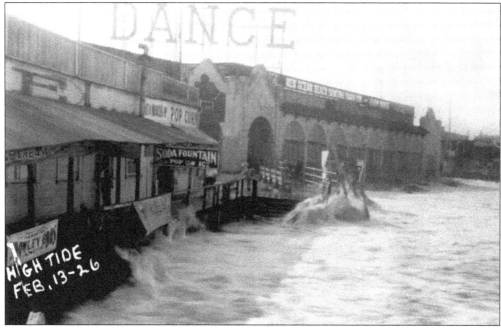

A storm and high tide in 1926 slammed against the triangular Flatiron Building's sweet shop and the New Ocean Beach Dance Pavilion and Beach Club at Newport Avenue and Abbott Street. After more years of storms, the damage to the Flatiron Building was irrepairable. The building was demolished in 1941.

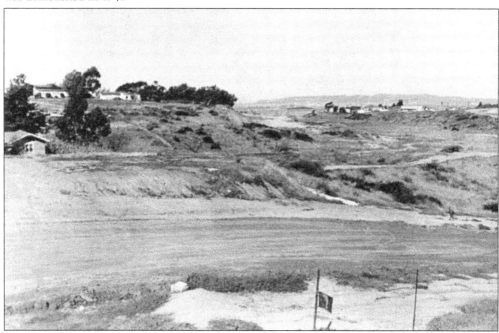

Catalina Boulevard is the dirt road (in the foreground) in 1955 before it became a main thoroughfare. The upper natural sandy canyon and marsh tidal flow channel ran behind the homes on West Point Loma Avenue. It became Nimitz Boulevard thoroughfare from Ocean Beach to Point Loma and the naval training center.

The rock barricade built on the sand was to protect Ocean Beach properties from storms and high tides. It was a 1944 public works project. Heavy rocks for the wall were excavated from a federal housing project site. These boulders were then furnished cheaply to the city by Roscoe Hazard.

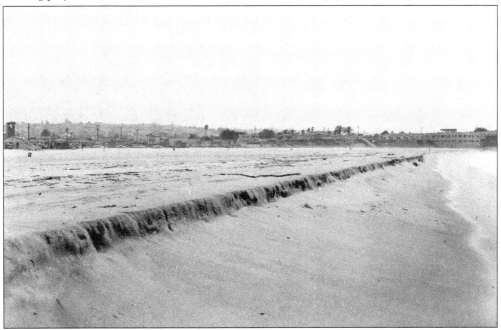

Ocean Beach's sand expansion project in 1955 extended the sand a long distance from the waterline. The larger beach was due to sand from the dredging of Mission Bay being placed on the long stretch of beach. The beach expansion caused the lifeguard station (left) to be farther away from the water's edge.

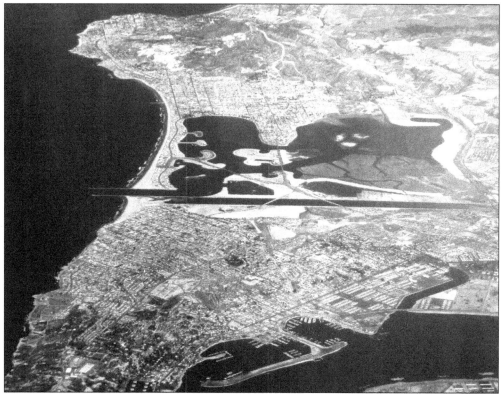

This aerial view shows the Mission Bay entrance and jetties, the flood-control channel, and the many dredge and fill areas, including the area where Robb Field would go. Two new bridges replaced the old Mission Bay Bridge that was removed because it was too low for large boats to clear.

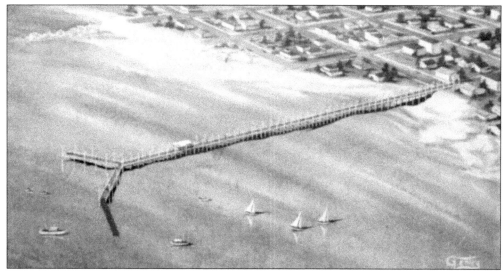

This painting by female artist Gentry hung in the Ocean Beach Hardware Store in the 1960s as part of a fundraiser to build the new Ocean Beach Pier. The pier extension painted on the T-shaped part was added for a second successful fundraiser to extend the pier toward the reef in hopes of improving the fishing. (Courtesy Weidetz family and OB Hardware.)

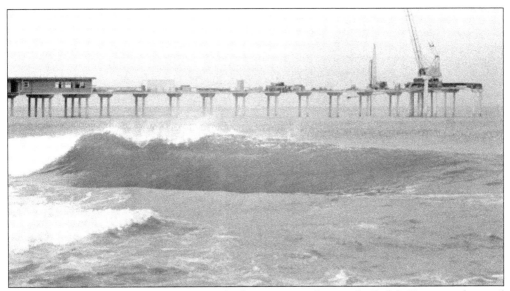

A new, T-shaped Ocean Beach Pier was built at Niagara Avenue by Ralph Teyssier, who used state-of-the-art technology and many tons of concrete in the construction. The pier had set a record as the longest municipal fishing pier on the West Coast at its opening in 1966.

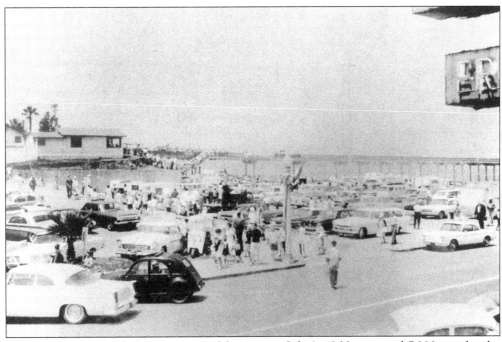

The new Ocean Beach Pier opening celebration on July 2, 1966, attracted 7,000 people who watched the parade and ribbon-cutting ceremony. Attendees listened to an Ocean Beach band with local musician John Tafolla, who played again at the Ocean Beach Pier's 50-year anniversary celebration.

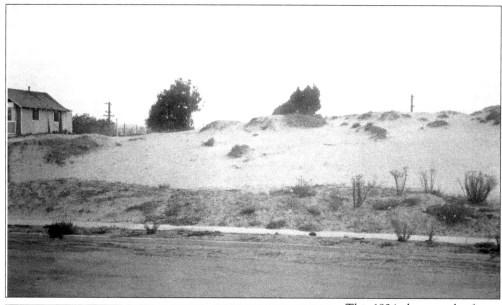

This 1924 photograph of Cape May Avenue shows the sand dunes that filled a large section of Ocean Beach. The dunes stretched westward from Bacon Street to the beach and from Newport Avenue before gradually tapering at the northern end of Ocean Beach. The sand was built on or used in construction materials.

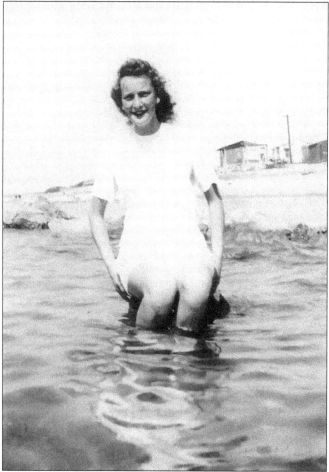

In 1945, teenager Jane Spencer (Meiners) enjoys the beach shallows during high tide at the foot of Saratoga Avenue. The beach shacks that line the sand are vacation cabins or small homes. The city removed some of the cabins close to the water before the rocks were placed on the seashore.

Two

HISTORIC HOMES
AND COTTAGES

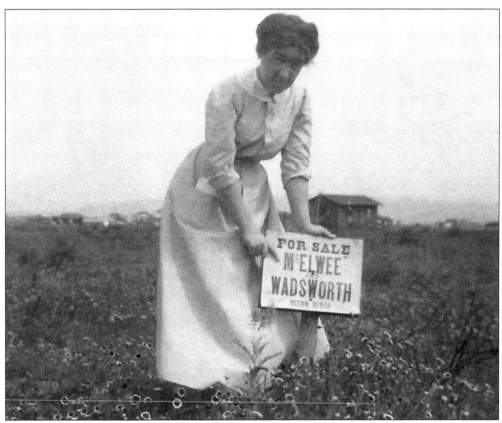

Mary (Peace) McElwee puts up a For Sale sign for her and husband Frank McElwee Jr. I's successful, longtime Ocean Beach real estate business. Unfortunately, Ocean Beach had its realty scoundrels, the most notorious being speculators Billy Carlson and Frank Higgins, the founders of Ocean Beach in 1887, who moved on after several scandals. Fortunately, many people who came Ocean Beach built or bought wonderful homes that exist today. The Ocean Beach Community Plan and the Ocean Beach Historical Cottage Program have helped retain many of these quaint homes that the residents love and have restored. (Courtesy McElwee/Peace family.)

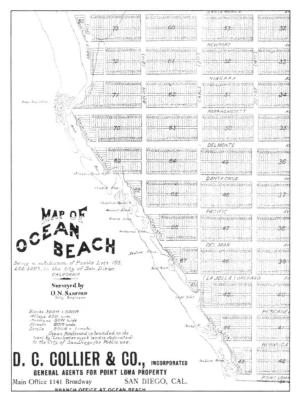

This D.C. Collier & Co. promotional map of Ocean Beach shows the names of streets, beaches, and scenic rock formations. Collier's home sat on the edge of the cliff on Pacific Avenue (later renamed Coronado Avenue). The main street to run through town was Defoe (Fourth), which, after this map was made, was renamed Sunset Cliffs Boulevard.

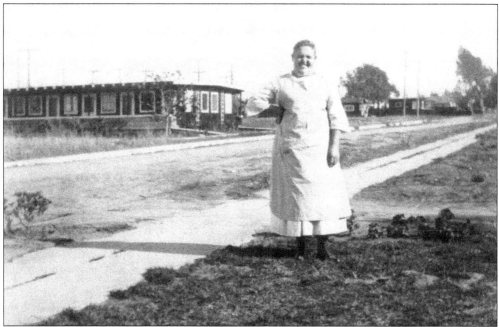

Early Ocean Beach infrastructure projects were done by the city in stages. In front of Dora (Mehling) Turskey's home on the 5000 block of Muir Avenue, the power lines have been put in and sidewalks have been built, but the road remains dirt. People mistook dirt roads for alleys and alleys for roads.

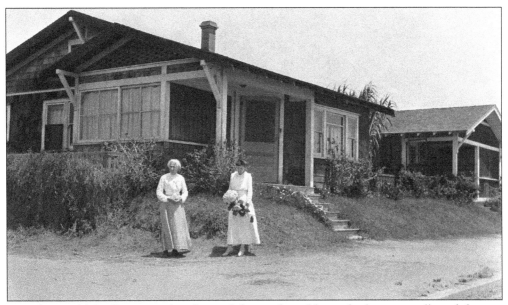

Grandma and Mrs. Bates stand in front of their redwood home built on a small sand dune at 5015 Cape May Avenue in July 1919. A curb has been put in, but the road and sidewalks are still dirt.

This sunrise over the hills was photograph at Cape May Avenue from a sand dune next to the Bates home (right) in 1924. By this time, sidewalks were built, but the street was still dirt. A large four-story apartment complex built in 1967 replaced the Bateses' and their neighbors' homes.

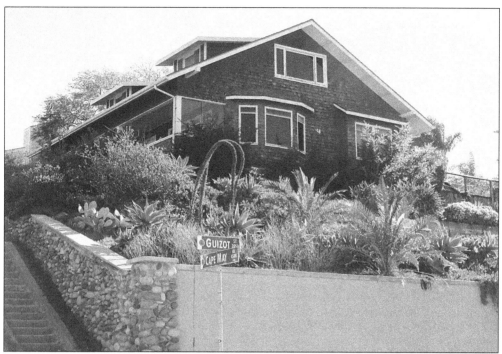

Richard and Carol Callejon restored their large 1915 Craftsman at 4493 Cape May Avenue in Ocean Beach Heights. A 1923 advertisement read, "For sale or exchange, a beautiful home of five large rooms, two kitchens, two coolers, a screen porch, three open porches, gas and electric, modern conveniences, ten acres fine gardening soil," and then boasts the finest view one ever saw. The property is no longer 10 acres, but the house is impressive. (Author's collection.)

Schoolhouses were used before the Ocean Beach Elementary School was built. The previous owners of 4644 Santa Monica Avenue said that their house was once an early schoolhouse with a shelf-lined room for the school's library. In this 1950 photograph, the former schoolhouse is again a home.

Gen. George Patton's daughter's 1935 home was moved from the wooded area of Point Loma on Catalina Boulevard to 4666 Cape May in Ocean Beach. It was placed at an angle, with the entrance at the west side of the lot instead of the front facing the street, so it would fit on the lot and get the best sunlight in the kitchen each morning. (Author's collection.)

The Del Mar Avenue Torre Del Mar Apartments (on the left) were a clothing-optional apartment complex in Ocean Beach's hippie heyday. The white structure next to it was once a carriage house for a larger building that had sat on the cliffs' edge and been taken down long ago. Unfortunately, the carriage house was badly neglected, then torn down in 2016. (Author's collection.)

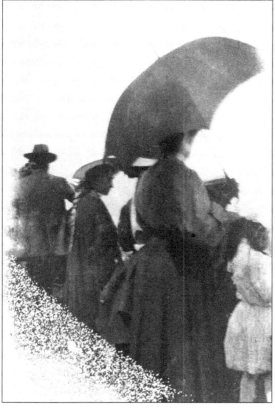

John W. Rankin, a retired schoolteacher, and Emma E. (Pogue) Rankin purchased Lot I at 4657 West Point Loma Boulevard in 1905 for $10. Constructed from 1910 through 1916, the house was one of the earliest California Craftsman bungalows built. Rankin's daughter Margret also lived in the home; she became the Ocean Beach librarian for nearly four decades. The Rankin Craftsman was refurbished to its original 1910 condition by owner Daniel Bille, who received the San Diego City Ocean Beach Cottage Historical District Designation. He found both a photographic negative (left) that was over a century old, in an interior wall of a built-in china cabinet; and proof of work done by John W. Rankin, when the face boards removed from the doors showed the inscribed initials "J.W.R." (Left, courtesy Bille family.)

Harold K. Rankin built his home across the street from his uncle John W. Rankin, on the easternmost end of West Point Loma Boulevard before it terminated at Harold Canyon (now Nimitz Boulevard). The home was a San Diego Craftsman, with a river stone patio wall and an attached boat dock that sat on the marsh (now a park). Harold was the postmaster general for the Ocean Beach post office from 1920 to 1940.

The entrance to Ocean Beach Park on Sunset Cliffs Boulevard and West Point Loma Boulevard offers a welcome historical sight just to the west: a group of quaint refurbished cottages. These cottages also sit on the edge of Rob Field Park, which was once False Bay. (Author's collection.)

The lot at 4770 West Point Loma Boulevard (left) was part of the 1909 Ocean Beach Park Annex and the home built by C.W. Fox in 1911. Charles Doster Lehew and wife, Marion (Clarke) Lehew, seen in 1950, bought their home with a lathe wood boathouse and arboretum in the 1930s. The Lehews previously owned the Wisteria Cottage on Niagara Avenue. The Monterey cypress on West Point Loma Avenue was planted as part of the earlier D.C. Collier tree project seen on page 13.

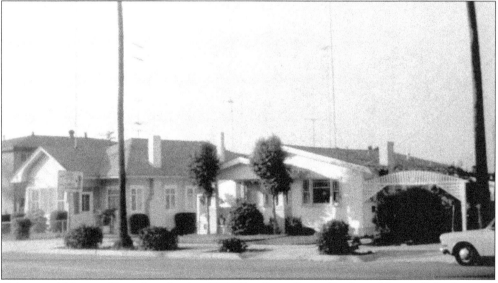

Calvin and Virginia Davis bought the 4770 West Point Loma Boulevard home (left, the same house seen in the previous image) in 1954. The Monterey cypress had been removed in 1969. The lathe wood house at 4764 West Point Loma Boulevard on right was built in 1925.

The 4764 West Point Loma Boulevard lot contains three lathe wood cottages. One faces the street (pictured in the previous image); the other two, seen in 2007, face the park and sit above the former seawall and staircase. The small boathouse and back cottage once sat on pilings over the marsh that was part of False Bay. (Author's collection.)

Lisa Davis, seen here in 1972, stands against the gate in her family's backyard at 4770 West Point Loma Avenue (pictured on page 32). The sand and scrub area behind the fence was formerly part of False Bay. The City of San Diego turned the marsh into a grassy park and dog park.

In 1915, Marion Clarke stands on the porch of her first home, on a large lot at 4762 Niagara Avenue. The property has a small barn and had a brackish well. Many years later, this cottage would be celebrated for its wisteria vines that Clarke planted. Now, the vines cover the porch and a large section of the yard.

Local historians are happy that the 4677 Niagara Avenue house built in 1913 remains in place today. Plans to demolish, excavate the hillside, and build two large multilevel homes were canceled. A new owner bought the historic home and property to live in, saving it from demolishment. (Author's collection.)

Adam (left) and Michael J. Mehling look dapper in 1939 in front of the decorative lattice attached to the house at 4929 Muir Avenue. The Mehling family owned this house, the one next door, and two across the street. Unfortunately, this home and the one next door burned down.

This photograph of the Mehling home with their car out front on Muir Avenue shows the nearby homes and backyards with neighbors' laundry hanging out on lines to dry. By 1939, the palm trees that had been planted years before along main streets had matured and can be seen above the rooftops.

The 4604 Pescadero Avenue home, built in 1893 and owned a by William C. Archer, was the first real home not considered a vacation shack in Ocean Beach. The house still exists; though it has been remolded, parts of the original remain. The Torrey pine and orange tree are still on the side of the house.

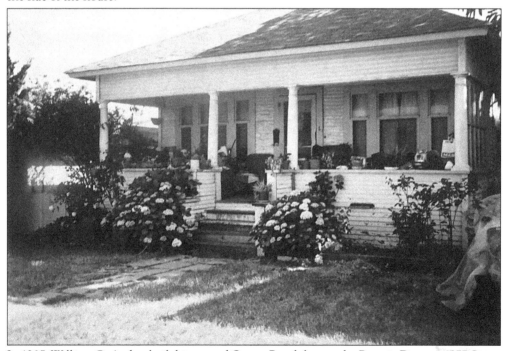

In 1905, William C. Archer built his second Ocean Beach home, the Bonnie Dune at 4977 Santa Cruz Avenue. The home was built in a popular style of the early 1900s that included a large deck. The deck was the perfect spot to watch the trolley car pass down the street.

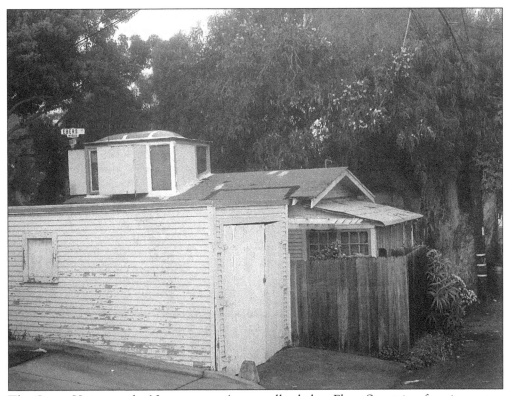

The Green House on the Narragansett Avenue alley below Ebers Street is a favorite among OBceans, with a funky skylight loft addition with an attached street sign. The old part of the cottage still has its original outside pipes. (Author's collection.)

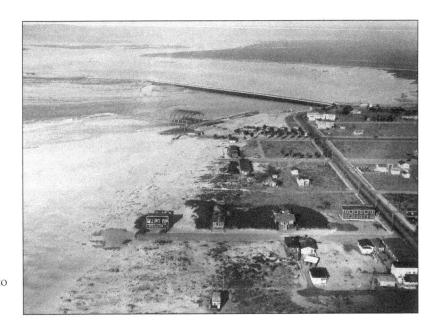

Ocean Beach looked quite different in 1924 than it had a decade before. By this time, Wonderland (now Dog Beach) was a skeleton of framing and dilapidated foundations. Its office was moved and refurbished into apartments on Lotus Street.

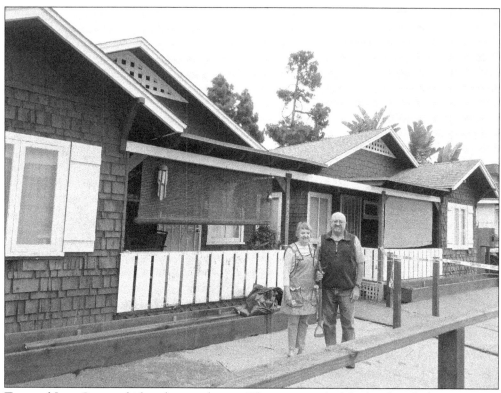

Tom and Jane Gawronski love historic homes. They are proud of the hard work that went into the restoration of their over-a-century-old, four-plex, historically designated cottages in the middle of the 4900 block of Narragansett Avenue. (Author's collection.)

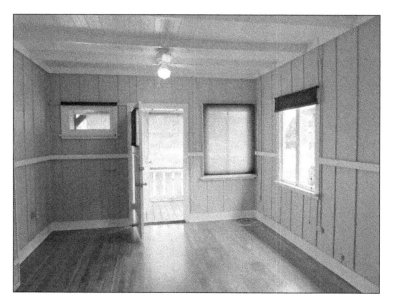

The Gawronskis' historic Narragansett cottage front unit's interior has the original single-wall construction and wood ceiling. Months of work went into removing multilayers of linoleum flooring and restoring the original beautiful wood floor. (Author's collection.)

Three

AT THE BEACH

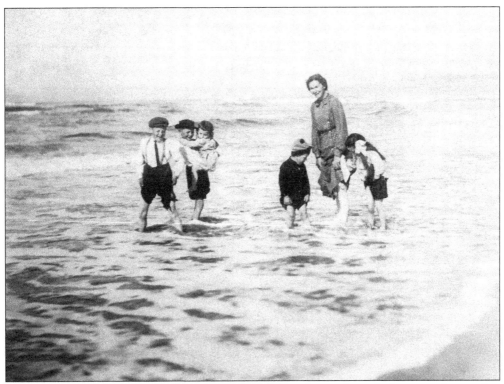

The ocean is the main attraction in Ocean Beach. Beachgoers love the long, sandy stretches of beach, especially on a warm day. The scenic cliffs draw people in with coves, tide pools, and rock formations, where visitors are surrounded by beauty. Folks go to the beach to play, relax, swim, improve their health, pose for photographs, tan, and participate in a number of activities. The Varney family moved to Ocean Beach in 1914, where they enjoyed the beach (seen here), as Joe, Charlie, Winnie, Walter, Mary Morse Sparrow Varney, and Ruth Varney (Held) play in the surf. As an adult, Ruth wrote the book *Beach Town* about the history of Ocean Beach. With historian and writer Carol Bower, she was the cofounder of the Ocean Beach Historical Society. Generations of the founding families still live on the peninsula and play at the beach.

Two women standing on the cliffs are bundled up in their long wool coats and hats to watch the large white waves from off in the horizon roll into Ocean Beach. The surf batters the cliffs and surges through tide pools on this blustery day.

These Ocean Beach tide pools sit where the sandy beach ends and cliffs start. This young boy in a wool swimsuit stands in his bare feet on the mussel-covered rocks while he peers intensely into the tide pools, likely looking for sea life or other treasures. (Courtesy McElwee/Peace family.)

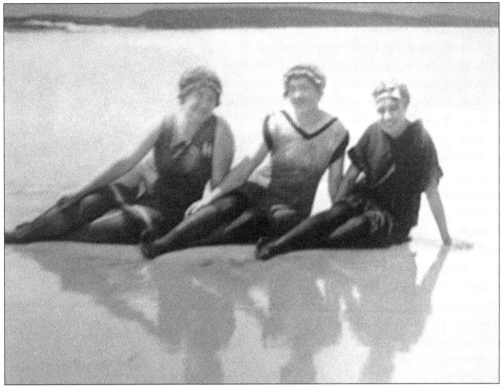

Ocean Beach's timeless beauty is found on the sandy shorelines and reflective waters. The glassy sand inspires these three water goddesses to pose with large smiles as the photographer captures the moment on film and in their reflections.

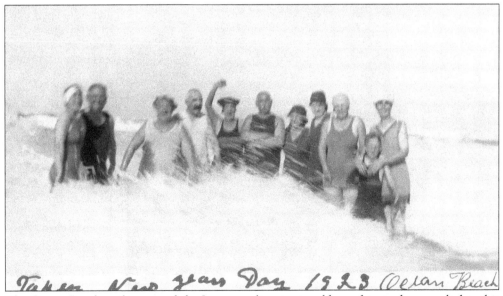

The Ocean Beach surf is up, and the January salt water is cold as a fair-sized wave splashes this fun-loving group of locals clad in their wool suits. Facing the elements was worth it to get this memorable motion shot, taken on New Year's Day in 1923.

Sunbathers, other than the fellow in the suit, enjoyed the warm sand, sun, and ocean for fun and their health. Benbough's Ocean Beach Bath House, with its lovely arches, opened in 1914. It rented swimsuits, towels, and umbrellas and sold fresh seafood, hot dogs, ice cream, and other goodies.

An Ocean Beach family in the 1920s has the water and waves to themselves as they frolic in the shorebreak. Long strands of eelgrass, a form of ocean grass (not seaweed) has washed ashore onto the sand.

Marion Clarke wears stylish beach attire with a matching parasol. Her mother visited Ocean Beach in 1905 and was quoted in a paper as saying, "When I first saw Ocean Beach, there were only three houses there." She and her husband, John Clarke, moved to Ocean Beach in 1915 and had their daughter Marion and five sons.

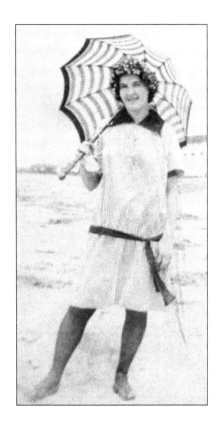

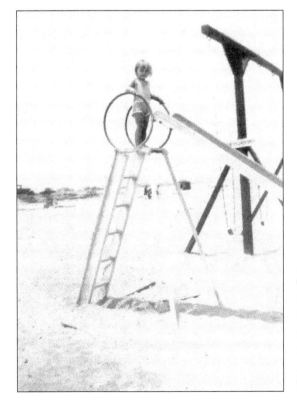

Carol Hart (Bowers), seen here at age two in 1935, enjoyed the slide at the Ocean Beach playground at the beach. She lived on the hill on Newport Avenue and later attended Ocean Beach Elementary School, followed by other local schools. She became a writer and publisher and cofounded the Ocean Beach Historical Society in 1994.

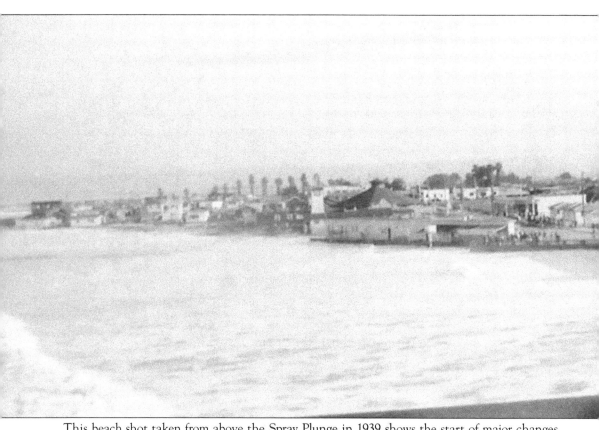

This beach shot taken from above the Spray Plunge in 1939 shows the start of major changes caused by several years of major storms that pounded the shoreline and coastal buildings. The

The owners of Camp Holiday Auto Court (seen on page 45), next to the Silver Spray Apartments and Hotel, had bright yellow wooden arrow signs (pictured) hung on the corners of main streets that crossed Niagara Avenue. The signs help direct vacationers to the seaside Camp Holiday Auto Court.

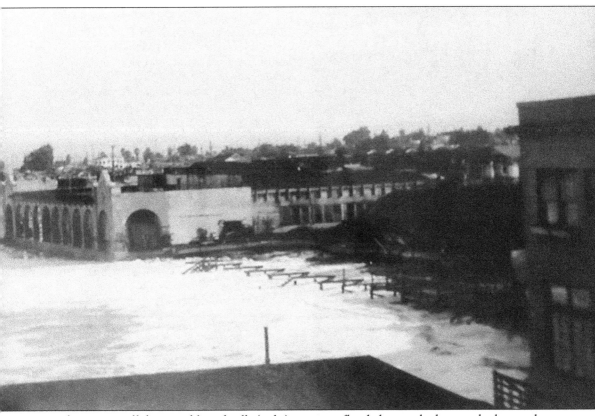

wood was torn off the raised boardwalk (right), cottages flooded or washed away, the battered Flatiron Building was torn down in 1942, and the lifeguard station was damaged.

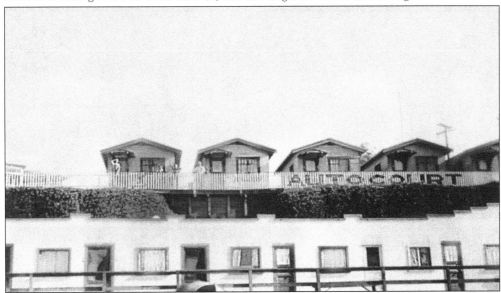

Camp Holiday Auto Court's cabins, built in 1923, overlook the ocean. The top cabins still exist as rentals. The lower rows of connected units on the wood boardwalk were short-lived and replaced by landscaping. (Courtesy McElwee/Peace family.)

OCEAN BEACH
· ON POINT LOMA ·

CALIFORNIA

BATHING - FISHING - BOATING
SAN DIEGO'S RESIDENTIAL BEACH

This early brochure highlights how visitors can enjoy Ocean Beach. In the early 1900s, the southern boundary of Ocean Beach ran west of Froude Street, down Point Loma Avenue, and over to Adair Street alley. Spalding's 1915 Sunset Cliffs Park was promoted as part of Ocean Beach, as seen on this brochure and many of the early postcards.

Ocean Beach–born Lincoln G. Rock stands left of his siblings on the tide pool rocks. They also swam at the Spray Plunge (right). Lincoln became an Ocean Beach lifeguard after graduating from Point Loma High School. He attended San Diego State University, where he met his future wife, Olive Burnett. Lincoln became a teacher and administrator with San Diego city schools.

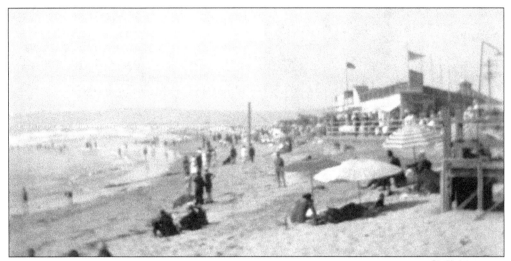

On this vibrant corner by Newport Avenue and Abbott Street was the popular 1914 Flatiron Building that was used as the Ocean Beach Woman's Club clubhouse. It was demolished in 1941 after heavy storms caused major damage. Insightfully, the triangular parcel was turned into a grassy public park—instead of allowing rebuilding in the flood zone.

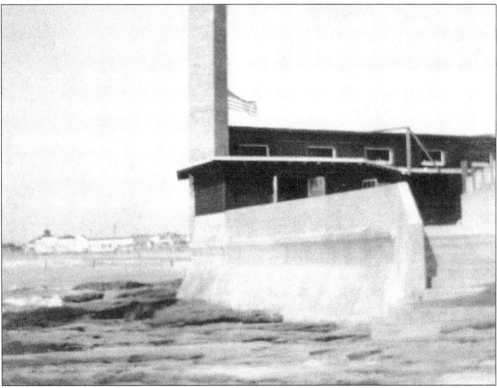

The Silver Spray Plunge was owned by Roy Riner and built in 1919 over the tide pools next to the Sliver Spray Apartments and Hotel. The Silver Spray Plunge had hot water and was touted as the finest saltwater pool. It cost two bits (25¢) to swim in the pool and another 10¢ to rent a swimsuit. Long-distance champion swimmer Florence Chadwick had been a swim instructor at the Silver Spray Plunge.

These three proud local lads can barely hold the heavy tunas they caught. These large fish likely made a lot of tasty meals for the boys and their families. Word on the peninsula would quickly spread when there was good fishing along the coast or at the pier.

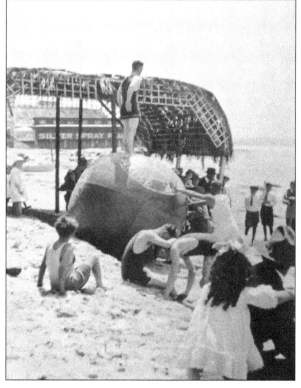

Ocean Beach had many health and fitness events on the beach. Swimming and surfing demonstrations in the ocean given by Olympic gold medal champions Johnny Weissmuller and Duke Paoa Kahinu Mokoe Hulikohola Kahanamoku were very popular. Many children gathered at the beach to watch the athletic event, which included wrestling matches and feats with a large leather ball.

Lovely Marion Clarke models fresh out-of-the-ocean bladder kelp over her swimsuit. Kelp was popular among the women as an early fashion trend for silly, fun photographs and competing in the popular Ocean Beach seaweed swimsuit contests held at the beach.

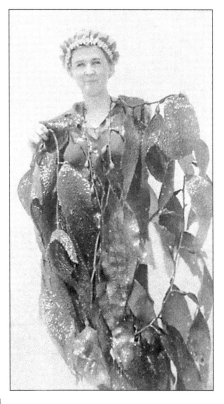

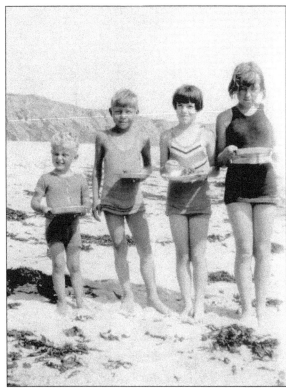

A group of young, hungry, sun-drenched children hold their plates of goodies at a beach picnic in July 1928. The sandy beach below the cliffs is full of dried kelp and eelgrass that had washed ashore. (Courtesy McElwee/Peace family.)

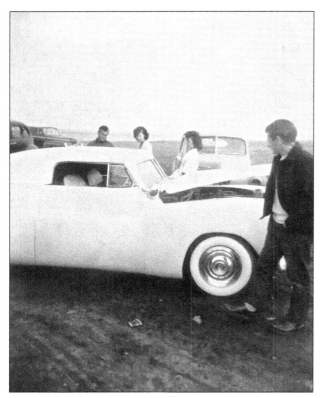

In the 1940s and 1950s, Ocean Beach's beach was a casual meeting place to park and gather with friends or take dates. Local car buffs would show off their hot rods or custom cars and check out the other guys' hot automobiles, like the white one with cool matching whitewall tires seen here. (Courtesy Mehling family.)

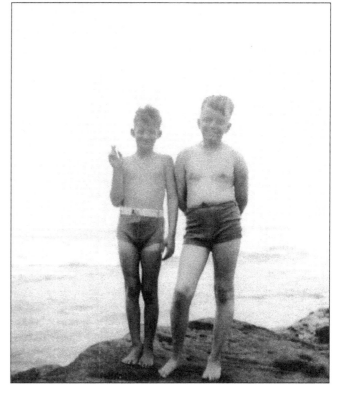

Ocean Beach was paradise to childhood friends Ned Titlow (left) and Frank McElwee III. They loved to swim at the beach and Silver Spray Plunge, explore the tide pools, and fish. As an adult, Titlow gave Ocean Beach Historical Society walking tours full of humorous stories about antics from his boyhood days.

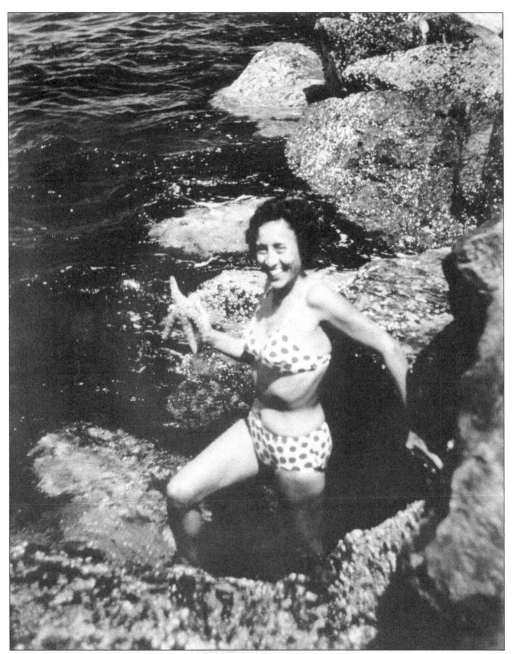

The original name for Ocean Beach was Mussel Beds. Black mussels covered the local tide pools. Willamartha Aiken, clad in her polka-dot swimsuit, scaled the rocks to show that Ocean Beach was home to starfish and other sea life that included barnacles, crabs, abalone, and mollusks. Over a half century later, much of the tide pool's sea life is harder to find or completely gone due to collecting, overfishing, and poor water conditions.

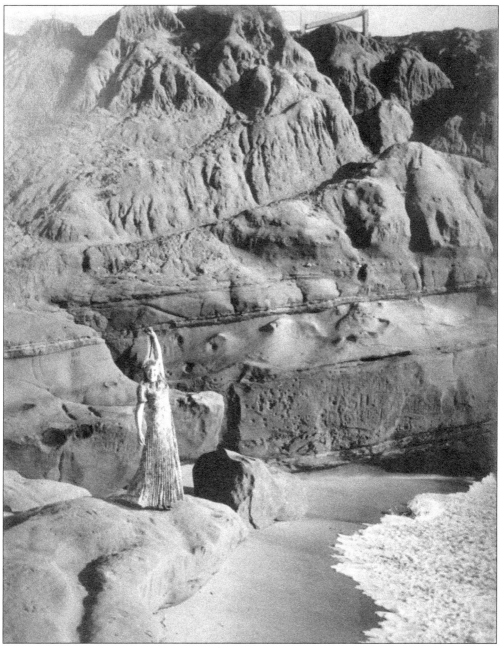

A smiling and fashionable Willamartha Aiken poses at Santa Cruz Avenue Cove. Originally named Crawfish Cove, it is actually two small, sandy, side-by-side beach coves, surrounded by cliffs and boulders. These coves, nestled among the sandstone cliffs, were enjoyed by sunbathers over a century ago. In the 1980s, these cliffs changed when seawalls and walkways were built. Many caves were filled in, and rock formations were concreted over.

Three local beauties in shorts sit on the pillar wall and help show off the city's beach beautification project. The decorative wall the gals sit on was on the corner of Newport Avenue and Abbott Street along the sand.

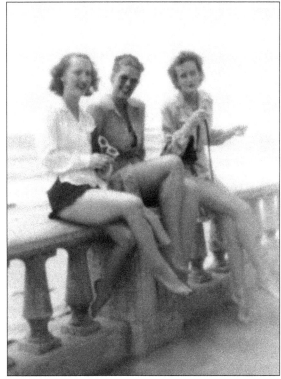

A flagpole and two palm trees are pictured in front of the decorative beach wall in 1955. The seawall was later replaced with a solid seawall and a staircase. The two palm trees and a flagpole are still on this corner today.

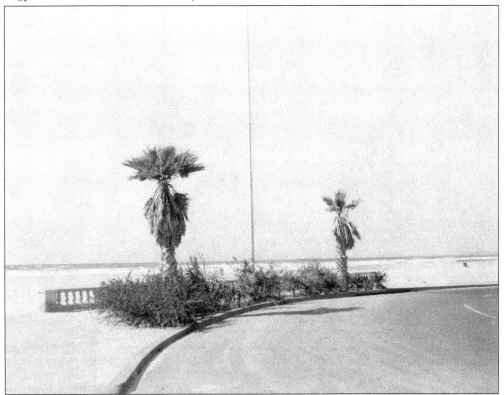

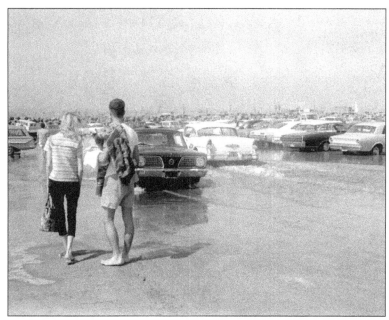

Automobile drivers were drawn to the wide-open area at Northwest Ocean Beach along the San Diego River. They would park or do maneuvers such as doughnuts. Many cars got stuck or flooded when the tide changed, as seen in this 1966 photograph. Fellows with big trucks made money towing out stuck vehicles. (Courtesy Stephen Rowell.)

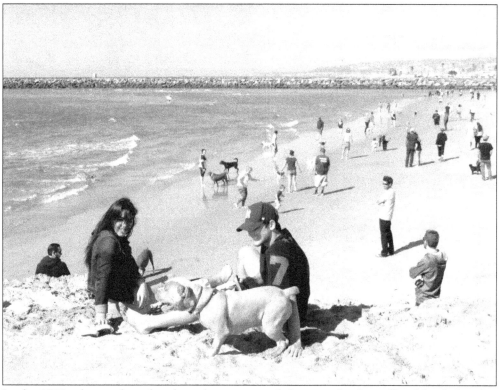

In the 1970s, the northern beach at the river mouth became the first official leash-free dog beach in the nation. By the late 1970s, vehicles were no longer allowed on the beach. Dog Beach, seen in this 2017 photograph, is very popular and has had successful campaigns to keep the beach clean. Amazingly, the least terns have formed a nesting area at the out edge of Dog Beach. (Author's collection.)

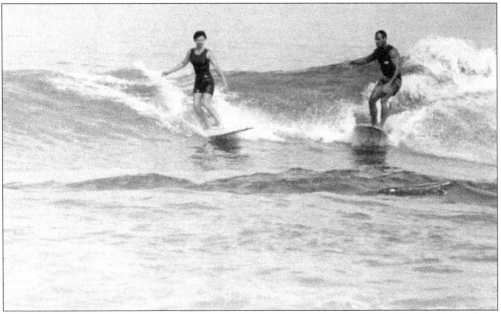

Ocean Beach's good surf breaks made it a popular surf spot in the 1960s. Locals Norma Jean Malcolm, wife of well-known waterman Marsh Malcolm, and Ed "Blackie" Hoffman share a wave while riding their longboards.

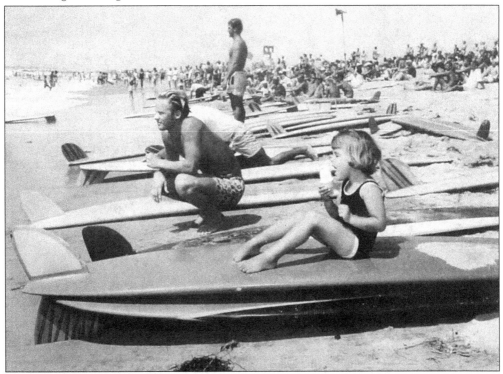

Numerous surf contests were held in Ocean Beach in the 1960s. Local Mark Denny, the blond squatting by his longboard, waits near the water with other contestants for their heat to start. The crowd looks on, but one young gal is more interested in ice cream. (Courtesy Claudia Jack.)

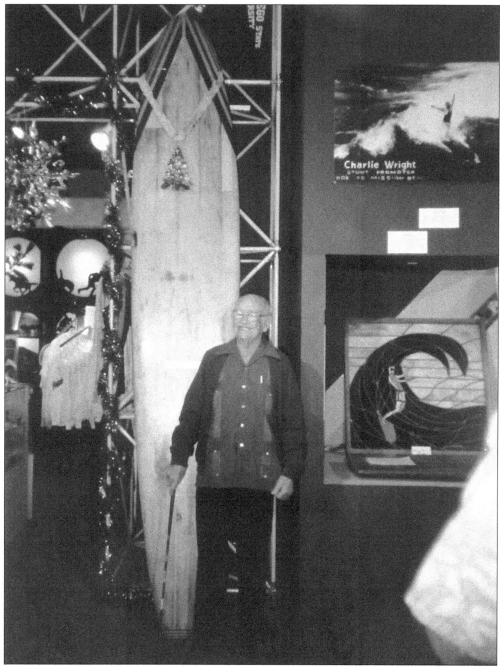

On August 14, 1987, Balboa Park's Hall of Champions honored Charlie Wright, a San Diego lifeguard, as the first San Diego surfer in its exhibit *Surfing San Diego*. Duke Kahanamoku came to Ocean Beach for the Hawaiian Exposition in 1916, where he met and taught Wright to surf. Wright built his own surfboard from solid redwood with a template made from Kahanamoku's surfboard. (Courtesy Williams collection.)

Two of Ocean Beach's most famous women surfers were honored at the Hall of Champions 1987 Surfing San Diego exhibit. At age 16 in 1924, Faye Baird Fraser was the first woman in California to surf, when she rode tandem with Charlie Wright (page 56), then surfed on her own. Joyce Hoffman was the women's champion in the World Surfing Championships in 1965 and 1966. The 1966 contest was held in Ocean Beach. (Courtesy Williams collection.)

The Sunset Cliffs Surfers program for the Ocean Beach Historical Society featured Cher Pendarvis (standing), a local surf legend who helps keep the history of women in surfing alive. James "Mouse" Robb sits next to his former tandem partner Ocean Beach's Judy Dibble, winner of the Makaha International Championships in 1960 and 1961, and Linda Benson (right), a Point Loma High graduate whose surf career started at age 15 when she won the 1959 Makaha International Championships and finished as runner-up in the 1964 World Surfing Championships, followed by other wins. She was the surfing stunt double in *Gidget Goes Hawaiian* (1961), *Muscle Beach Party* (1964), and *Beach Blanket Bingo* (1965).

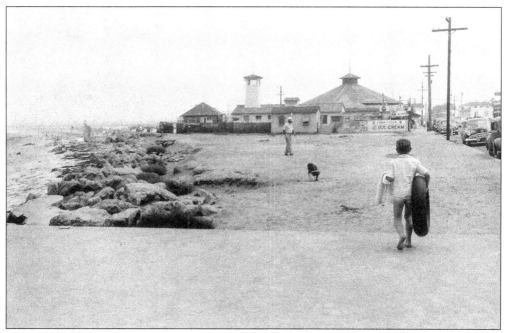

The old Ocean Beach Lifeguard Station, seen with its lookout tower on Abbott Street in 1955, stood next to the Cubby Hole and the furniture store that was previously the merry-go-round building. Earlier in the 1930s, the police had a holding cell on the back side of the lifeguard station. Before that, in the 1920s, the police cell had been across the street in the Sutliffe Building.

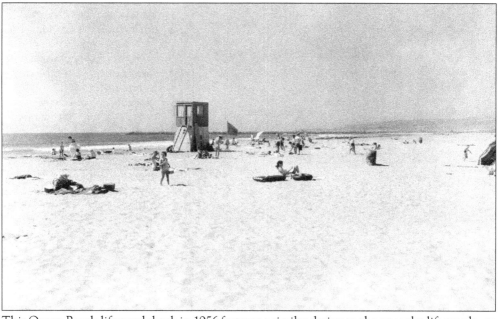

This Ocean Beach lifeguard shack in 1956 features a similar design to the ones the lifeguards use today. By having the lifeguard shack raised, the lifeguard's view is much better to see people in distress in the water. Unfortunately, this lifeguard shack burned down in the 1960s.

Four

MAIN STREET
MOM-AND-POP SHOPS

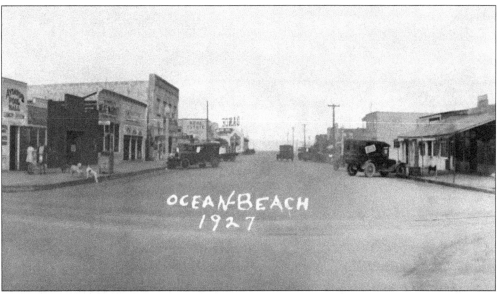

Local shops and services were popular and strongly supported by the Ocean Beach community throughout the town's history. In 1927, the commercial district on Newport Avenue catered to residents and tourists with an assortment of businesses that included a dance hall, the Strand Theatre, markets, real estate offices, and a pool hall. Later came shoe repair shops, bakeries, restaurants, and other businesses. Tourist attractions and businesses were popular near the beach on Abbott and Beacon Streets. The northern end of Ocean Beach had a strong business district until 1951, when the old Mission Bay Bridge that crossed over to Ocean Beach was removed. Over the years, businesses came back to that part of town. (Courtesy Faber family.)

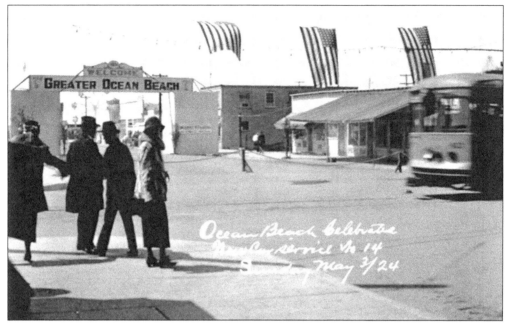

D.C. Collier brought the electric trolley car service to Ocean Beach in 1910. On May 3, 1924, Ocean Beach celebrated a new trolley service that dropped riders off on Beacon Street near the amusement park's welcome sign, where the Ferris wheel can be seen in the far background.

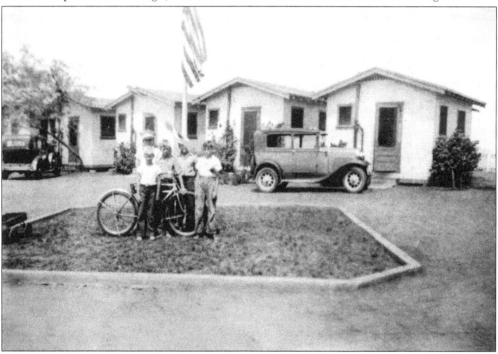

Camp Holiday Auto Court, seen here in 1933, attracted out-of-town tourists who stayed in the beach shacks that overlooked the ocean bluff. Many of these visitors bought properties from Camp Holiday owner Frank McElwee II, who was also a realtor and homebuilder. (Courtesy McElwee/Peace family.)

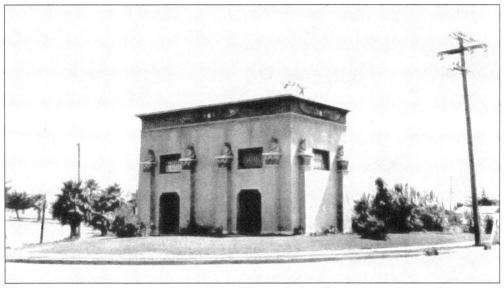

This elaborate 1924 Ocean Beach San Diego Electric Rail trolley substation was at the corner of Bacon Street and West Point Loma Avenue near the Mission Beach Bridge. The trolley transported many Mission Beach riders, who helped stimulate the local economy, to Ocean Beach. (Courtesy Eric DuVall.)

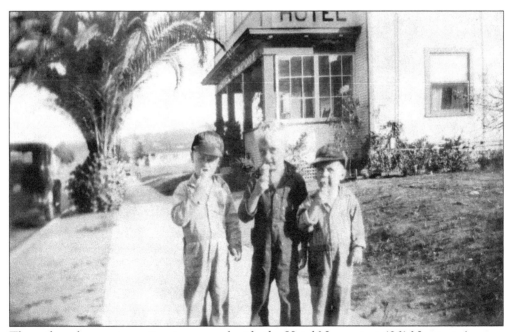

These three boys enjoy eating ice cream beside the Hotel Newport at 4961 Newport Avenue. Later, the name was switched around to Newport Hotel. Originally named the Pearl Hotel in 1909, it became a hostel in 1995. (Courtesy McElwee/Peace family.)

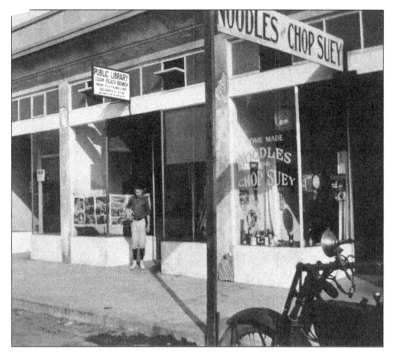

The Sutliffe Building storefront on the corner of Abbott Street and Santa Monica Avenue was the first Ocean Beach branch of the San Diego Public Library in 1916. An hours sign hangs outside. Inside was a room for the library and another for an office. The 1920s jail was next door, with a holding cell that shared the library wall. Remnants of the jail cell's column remain in Newbreak Coffee & Café.

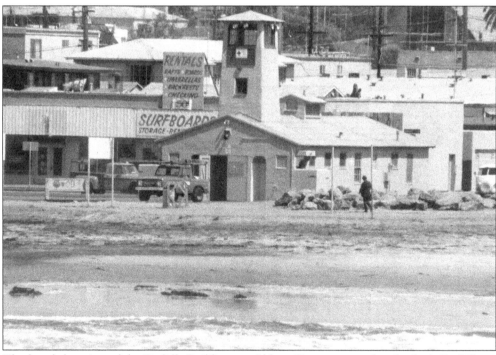

The beach location of the Sutliffe Building on Abbott Street was perfect for Jon's Surf Shop, and others that followed, since surfboards and accessories were fueling a budding industry in the 1960s. Across from Abbott Street was the original lifeguard station that faced a long stretch of sandy beach with good waves.

Kate Spani raised $200 for the original 1916 Ocean Beach Library to buy shelves and materials for furniture built by pioneer residents. Noise heard from the nearby amusement park was loud, but patrons were asked to speak in a whisper. (Courtesy Friends of the Library.)

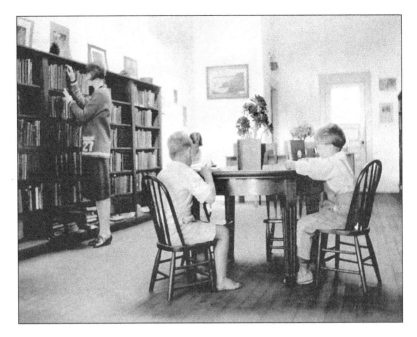

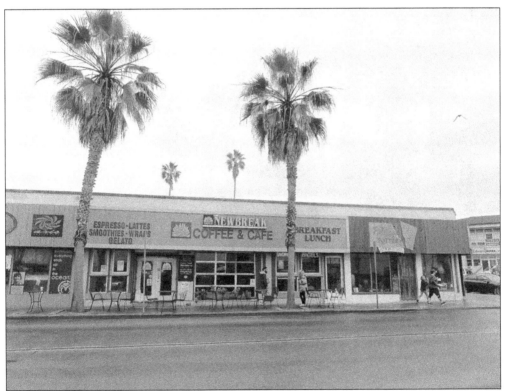

The first 100 years of the Sutliffe Building were filled with wonderful businesses that included a camera store, surf shops, jewelers, a bikini shop, coffeehouses, a leather shop, Buford's Candy Store, Falling Sky Pottery, and more. Famous musician Jason Mraz started his career playing to an adoring crowd on Saturday evenings in summer of 1999 at Newbreak Coffee & Café.

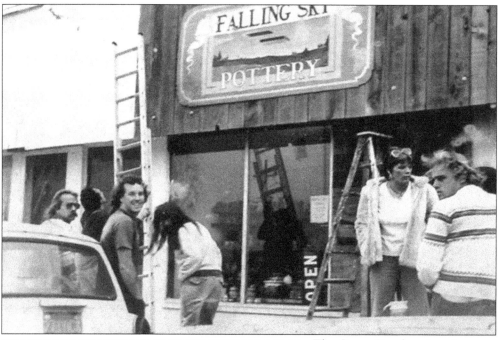

The Ocean Beach artisans' community created a number of businesses that opened in the Sutliffe Building storefront on Abbott Street in 1969. It became the longtime home to Stonehedge Leather and Falling Sky Pottery, whose gallery was located where the Ocean Beach Library had been in 1916. (Courtesy Falling Sky Pottery.)

Local potters opened Falling Sky Pottery in 1969 after remodeling and building a kiln on the shop's back patio. Renowned potter and teacher Isauro "Izzy" Elizondo runs the shop. He has immense skills in traditional ceramic and is known for his *neriage* pieces created using an ancient Japanese pottery technique. (Courtesy Falling Sky Pottery.)

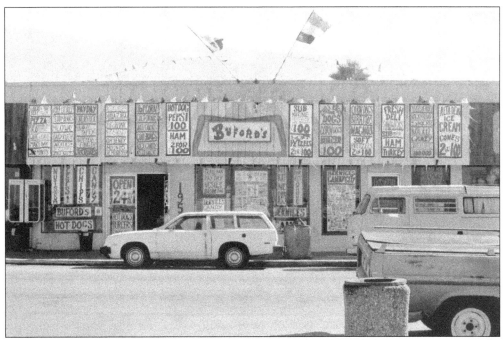

In part of the 1970s and 1980s, Buford Seals, a very colorful local character known as "the Candyman," owned and operated Buford's Candy Store at 1959 Abbott Street. Buford had countless types of candies, including kinds that people remembered from their childhoods. Newbreak Coffee & Café moved into the space in 1999. (Courtesy Stephen Rowell.)

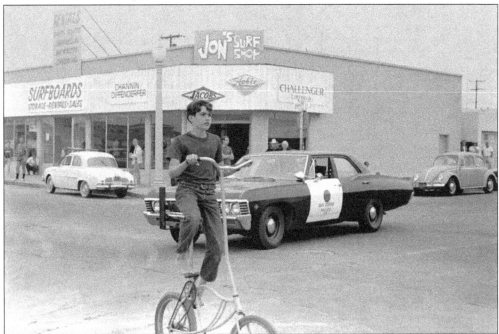

Jon's Surf Shop, also a surfboard rental, was the main business on the corner in Sutliffe Building in 1967. Here, a local kid cruises by on a funky makeshift bicycle on Abbott Street, past a police car. Odd makeshift bicycles were very popular in the 1960s and 1970s. (Courtesy Stephen Rowell.)

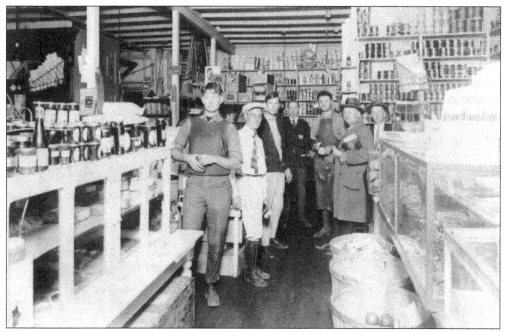

The Faber family's first grocery market, the Cash and Carry, was run by Guido Faber and opened in 1914 at 5010 Newport Avenue in Ocean Beach. The small market offered delivery service by horse-drawn wagons throughout the peninsula. A Ford Model T truck later replaced the horse-drawn wagon.

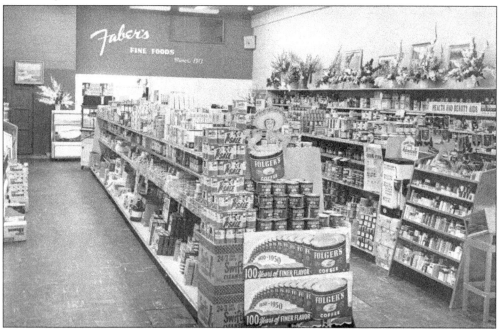

The Faber's Superette Market was open from 1948 through 1958. It was owned and operated by Guido Faber, his son Guido (nicknamed "Bud"), and Bud's wife, Ruth Faber, who helped with the displays. The Faber family later moved their store from one Newport Avenue location to another on the same street.

Glenn's Drive-In, a drive-up burger and malt shop on West Point Loma Avenue and Cable Street, was where the entrance to Robb Field is now. After Glenn's Drive-In closed, the site became several a more formal, sit-down restaurant. New owners remodeled the building, keeping only the gabled section. (Author's collection.)

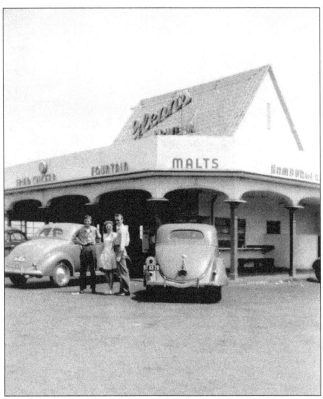

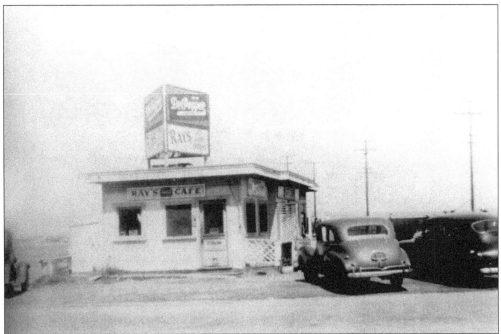

The Prathers owned Ray's Café in Ocean Beach on the water's edge of Mission Bay (formerly False Bay) near the foot of the Mission Beach Bridge, where they received a steady flow of customers. Unfortunately, when the bridge was demolished in 1952, Ray's Café's business slowed and it closed.

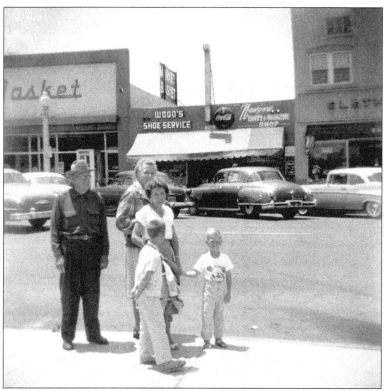

The Wood family stands across from their Wood's Shoe Service business on Newport Avenue that was a fixture in the community for decades. Also popular were the Market Basket grocery store and Robert and Anna Sakellarion's Newport Candy & Magazine Shop, which was open from 1942 to 1955.

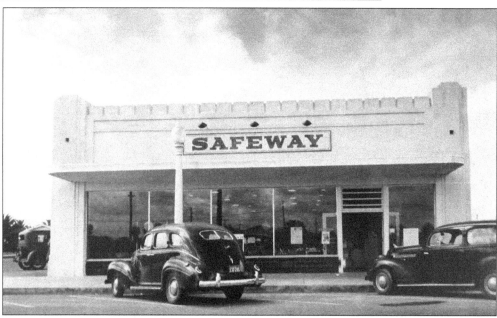

The Safeway opened in 1940 at 4905 Newport Avenue and had its own large parking lot. In the 1960s, Safeway moved into its signature arch-style market at Cable Street and Santa Monica Avenue. The Newport Avenue location was home to several furniture stores, followed by James Gang Graphics and Printing in 1977, until it moved in 1990. Once again, the building is now a furniture store.

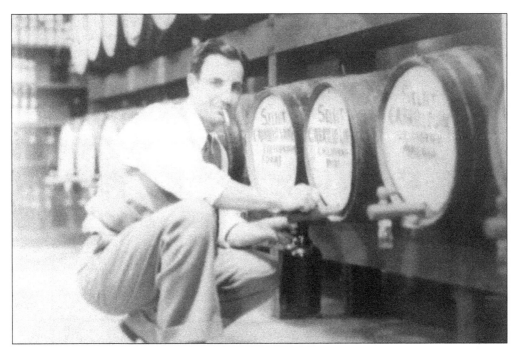

A to Z Liquor was at 1921 Bacon Street (left side of photograph below). The owner, Robert Sakellarion (above), shows how to fill bottles from his store's wine casks in 1935. Winston's has been at the Bacon Street location since 1986. Bank of America (below) was originally a Bank of Italy in 1927. Architect William Templeton Johnson designed the Mission-style building with a tiled entrance. Today, the building is a Starbucks, with a stucco exterior.

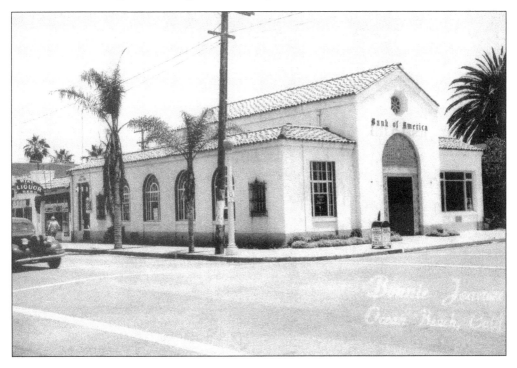

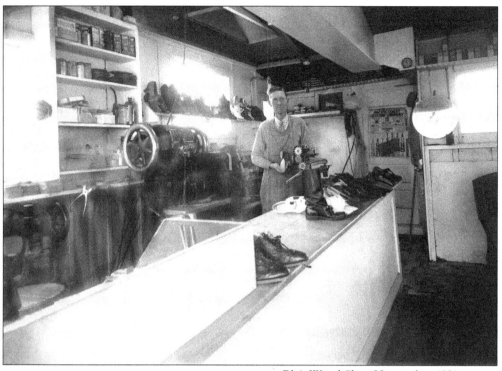

Bly's Wood Shoe Hospital at 4931 Newport Avenue was the Wood family's first shoe repair shop on Newport Avenue. Long before this 1940 photograph, this shop had been badly flooded during the 1916 storms, but the building remained standing.

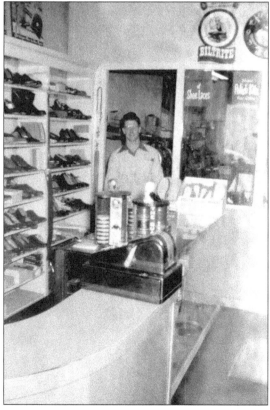

Bly Wood's son Bob ran Wood's Shoe Shop at a new Ocean Beach location at 4979 Newport Avenue. William "Willie" Johnson (seen on page 71), "the Shoeshine Man," worked with the Wood family for many years. (Courtesy Willie Johnson.)

"Shoeshine" Willie Johnson is pictured in front of Paris Magazine Store in 1970, visiting with little Adam Rowell as his father, Stephen, photographs them. Willie, a former sergeant in the Marines and friendly face in OB, shined shoes for over a half century and opened Willie's Shoe Shack on Newport Avenue in the 1990s. (Courtesy Stephen Rowell.)

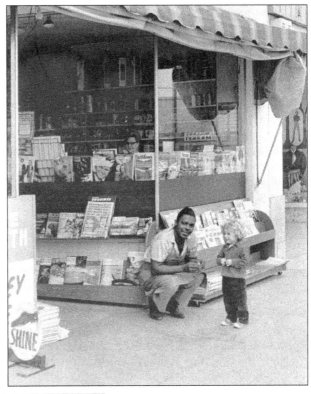

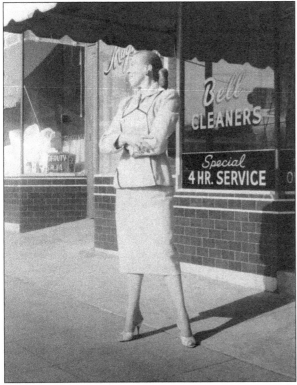

Willamartha "Willie" Farrington Aiken strikes a pose in her stylish tailored suit in front of Bell Cleaners. Shopping, dining, or seeing a movie at the Strand Theatre on Newport Avenue in downtown Ocean Beach was an occasion to dress up in the 1940 and 1950s.

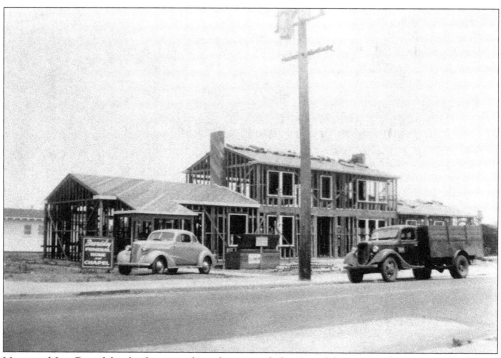

Vera and Joe Beardsley built, owned, and operated the Beardsley Funeral Home and Chapel. The building was constructed in the 1940s on the corner of Sunset Cliffs Boulevard and Narragansett Avenue.

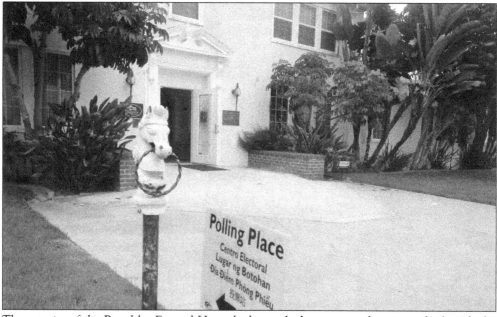

The exterior of the Beardsley Funeral Home looks much the same as when it was built with the addition of lush landscape. The original horse hitching post that was installed out front is still there today. Besides being a funeral home, it was also used as a polling station in 2014 and other years.

Beardsley Funeral Home owners Vera (left) and Joe Beardsley (center) lived nearby on Sunset Cliffs Boulevard. They were active in community, social, and business activities in Ocean Beach for over 30 years. The lady at right is unidentified. (Courtesy the Wade family.)

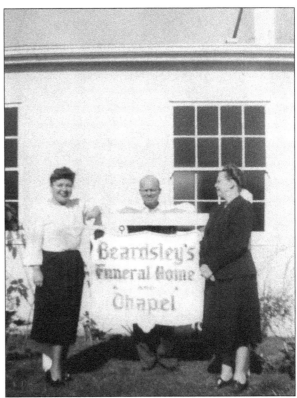

The Children's Energy Center was blue, and unfortunately, from a historical prospective, its story is also blue. The Kiwanis had the building moved from Camp Callian in 1951 to Santa Monica Avenue and Ebers Street to be the Ocean Beach Boy Scout building. Later, it became a preschool. In 2009, after local opposition and protest, the little blue schoolhouse was torn down and replaced by four nondescript homes.

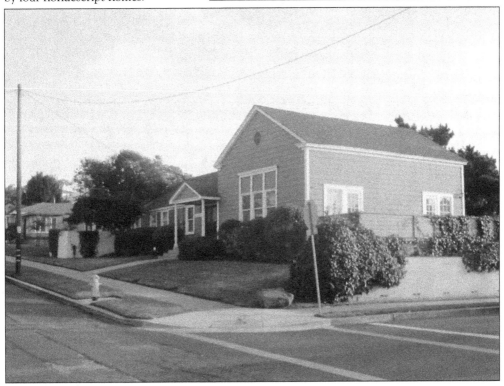

The Ocean Beach Dance Studio was operated by renowned dancer Lucile Iverson South, who was a child prodigy who embarked on a professional career at 16, was a featured dancer in stage productions, danced in movies, produced USO shows during World War II, and taught ballroom dancing at San Diego State University. Next door to the studio was Ocean Beach News.

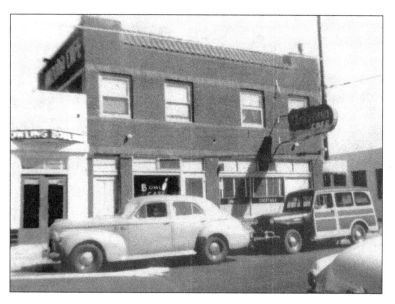

Former boxer and football player George Radovich opened the Arizona Cafe in 1943 in a building his father purchased in 1927. Next door, in 1946, the Radoviches opened the Ocean Beach Bowl, one of the area's first bowling alleys. It closed in 1982 and became the home of James Gang Graphics, which moved to Newport Avenue in 2017.

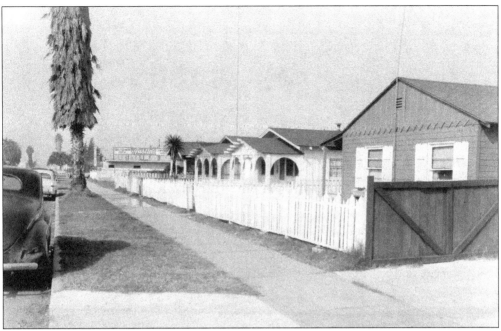

This photograph from 1955 shows the mid-4800 block of Santa Monica Avenue. There was a row of several charming white residential cottages with white picket fences. The same lovely historic Santa Monica Avenue cottages in the above photograph are quaint small shops in the 2012 image below. The palm tree seen in the westerly cottage front yard is now a tall, mature tree.

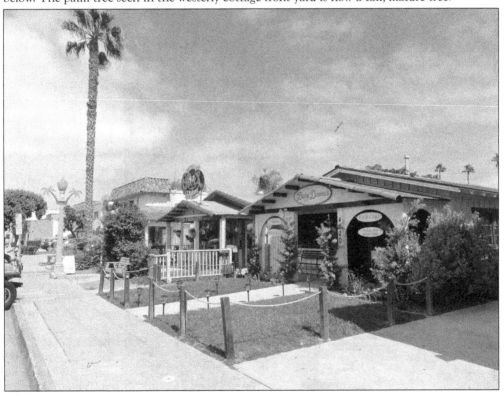

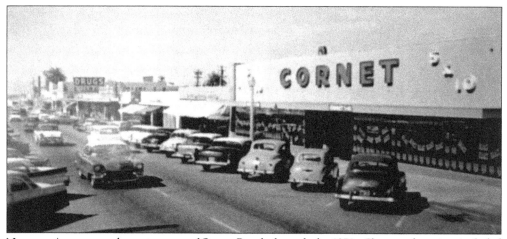

Newport Avenue was the main street of Ocean Beach through the 1970s. Shops and services included two five-and-dime stores, Cornet and Holmer's; several drugstores; the Ocean Beach Hardware Store; women's clothing stores; shoe repairs; liquor stores; bakeries; restaurants; and more.

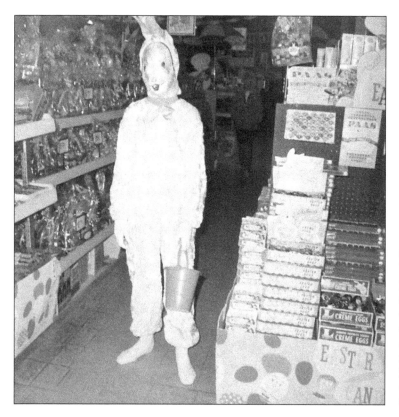

Cornet's Easter bunny sale promotion maybe should have been called "funky bunny of 1969." This is just one example of the five-and-dime store's friendly image that customers remember and cherish.

Hodad's became popular for its great burgers when Byron and Virginia Hardin opened in 1969 on Voltaire Avenue in Ocean Beach. In 1973, Hodad's was in its new beach location, north of the lifeguard station parking lot, beside Saratoga Park, where the musician plays.

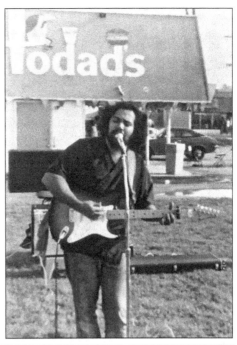

Hodad's reopened on Newport Avenue in 1991 under the helm of Mike "Bossman" Hardin. The funky-surfer burger joint gained a worldwide reputation as customers lined up down the block, under the Hodad's sign "Under a ~~Billion~~ Gazillion Burgers Sold!" Sadly, Bossman died in 2015, but friends reminded folks of what Mike said: "When I die, I want to return as myself!" Hodad's is now in the hands of third-generation Shane Hardin, Bossman's son. (Author's collection.)

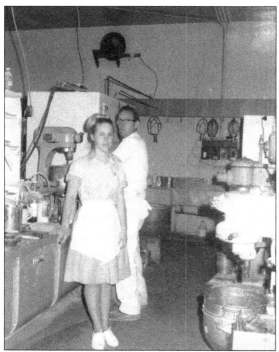

The Ocean Beach Bake Shop at 4857 Newport Avenue was open from 1956 through 1971. It was family owned and run by baker Lawrence E. "Pete" Peterson with his daughter Heidi A. Peterson, seen here in 1965.

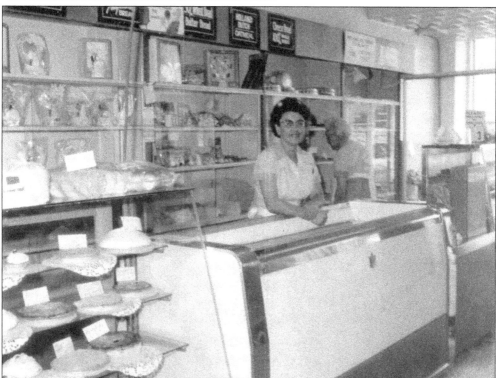

The Ocean Beach Bake Shop lunch counter lady, Olga M. "Babe" Peterson, served hot dogs, hamburgers, crab rolls, roast beef sandwiches, coffee, and bakery sweets. They were extremely busy on the holidays. The building had previously housed a fabric shop.

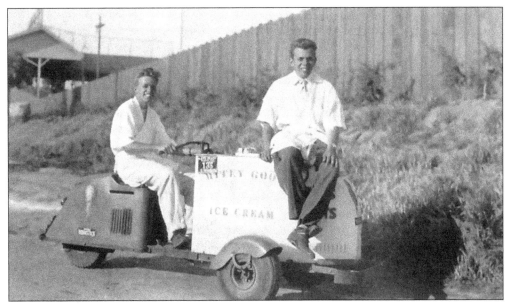

Clad in their white smocks, these young entrepreneurs, Jim Hart (left) and Keith Hart, work as ice-cream venders in Ocean Beach. They drove their makeshift "Mitey Good Ice Cream" vehicle to go serve their Ocean Beach customers.

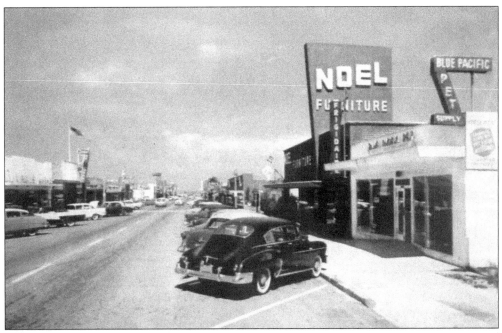

The Blue Pacific Pet Supply store and Noel Furniture in 4800 block of Newport Avenue and were locally owned. These were examples of the many local businesses that supplied goods and services to residents and tourists.

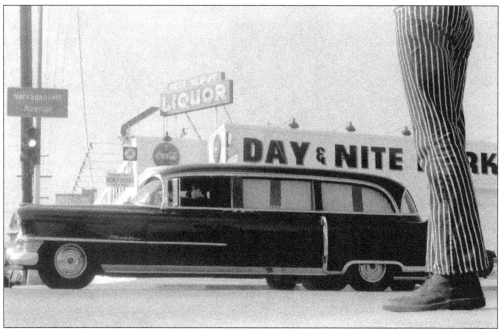

This cool 1960s photograph shows Day & Nite Market in the background on the corner of Narragansett Avenue and Sunset Cliffs Boulevard, which faced the dry cleaner on the east corner. The photograph was shot from the north across the street in front of the funeral home. The Day & Nite Market became Olive Tree Market in the 1970s. Olive Tree owner Christopher Stavros upgraded the market with a great deli, an extensive assortment of wines, and a tasting room next door. (Courtesy Stephen Rowell.)

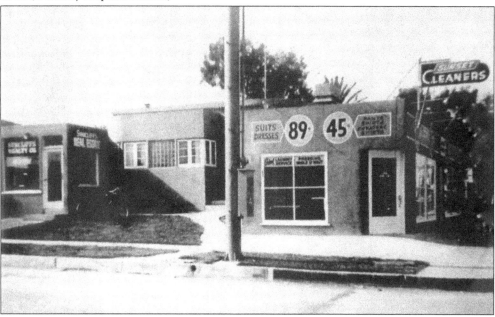

This group of attached buildings on the corner of Narragansett Avenue and Sunset Cliffs Boulevard was originally an Art Deco house. The building remained a home in 1950, but the house's garage became a realty office, and the yard on the corner became Sunset Cleaners.

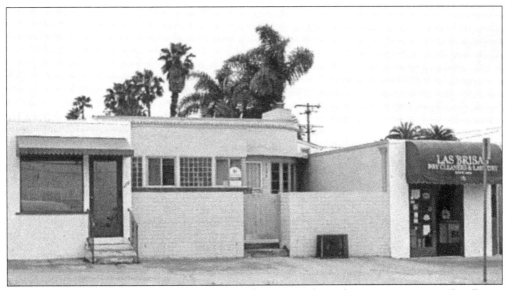

The same buildings seen in the previous image have gone through many renovations. Las Brisas Dry Cleaners and Laundry moved into the 1785 Narragansett Avenue storefront after being across the street to the north for several decades.

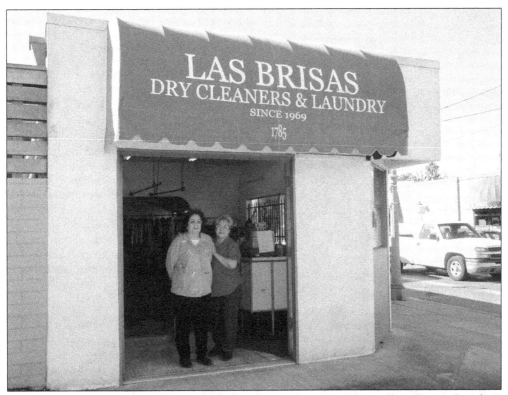

Las Brisas Dry Cleaners and Laundry longtime employees bid farewell to Ocean Beach as they get ready to close in February 2014. The shop became Bone Appetit, a pet supply store. (Author's collection.)

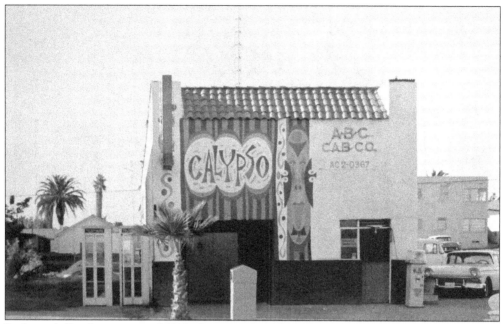

Built as a billiard room around 1915, the property at 5049 Newport Avenue went through many incarnations. It was an American Legion Hall in the 1950s, and the ABC Cab Co. split the building with the Calypso bar that adorned the face with a sign-mural in the 1960s. Later, it was several restaurants.

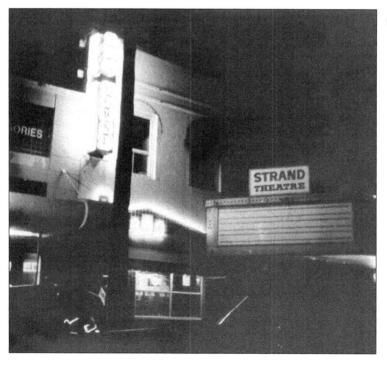

The Strand Theatre on Newport Avenue opened in 1925. Generations of moviegoers saw film classics, serials, surf movies, and cult classics, including *The Rocky Horror Picture Show.* To many resident's chagrin, the lights went out on the Strand marquee in 1998. Local business owners and a theater group tried to buy the theater, but obstacles stood in the way. It became a tourist-focused chain store. (Courtesy Lynn Vanderpot.)

Five

THE GREENING
OF OCEAN BEACH

Ocean Beach has a long green history. The sunny, fair climate helped many residents establish their own thriving gardens. Clifford Ausad, pictured here, who was an early resident of Ocean Beach, not only dressed the part of a farmer but also worked in his family's lush vegetable garden. In the early 1900s, peninsula residents' green inspirations and achievements came from legendary horticulturalists and renowned visionaries: David "D.C." Collier, Alfred D. Robinson, Albert Spalding, Katherine Tingley, and John D. Speckles. The trees and gardens they planted or inspired still grace parts of the community. The Ocean Beach Woman's Club, the Ocean Beach Community Garden, and many residents have also had a hand in local gardening. From the 1960s to the present, OBceans have lead the way in the local and national green revolution, in environmental issues, activism, organic food, water issues, fighting global warming, green businesses, local participation in the Ocean Beach community plans, historic preservation, horticulture, and more.

Ocean Beach's climate is perfect for cultivating fruit trees. In the Varney's backyard, Charles W. Varney demonstrates gardening techniques as he works on the family's fig and citrus trees. These are popular varieties of trees because they grow well on the peninsula and produce a lot of fruit.

The Mehling family, who lived on Muir Avenue, were water-wise gardeners in 1937. They planted drought-resistant gardens with succulent, cactus, and other low-water plants. They also landscaped with rocks collected from the nearby cliffs.

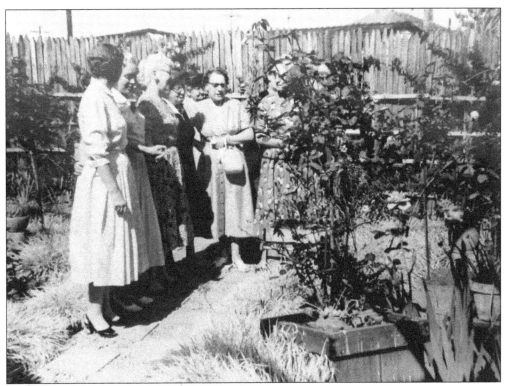

The Ocean Beach Woman's Club new garden department gave a clubhouse garden tour to members in 1956. Previously, in 1927, horticulturist Kate Sessions instructed the club about the best adaptive plants for beach cultivation, which inspired the group to plant hundreds of trees and shrubs in Ocean Beach.

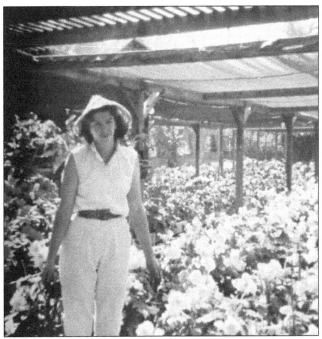

Ocean Beach resident Louise Brain (Peirson), a horticulturist in the 1960s, worked at the famous Rosecroft Gardens in Point Loma's wooded district. Rosecroft's founder, Alfred D. Robinson, the begonia expert, developed over 100 new varieties of begonias. (Courtesy Peirson.)

Vegetable gardens were popular in the 1960s. This garden, belonging to one of four cottages on Abbott Street, was located across from the old lifeguard station. A large commercial building now resides there.

Richard "Brownie" Aiken tends his thriving Ocean Beach vegetable garden. No overalls and T-shirts for him—he wears his time-period groovy-patterned bell-bottom pants when he gardens.

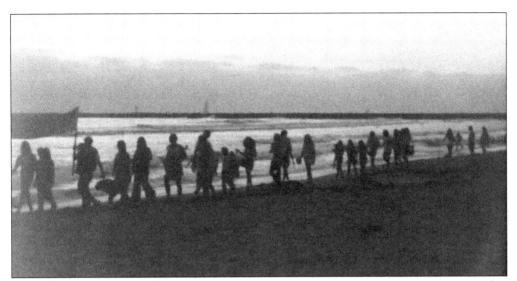

The Save Sunset Cliffs march was one of many Ocean Beach protest marches that started in the 1960s and continue today. Others protest issues include environmental causes, housing and planning, saving mom-and-pop businesses/opposition to gentrification, coastal protection, saving trees, and others. (Courtesy Robert Burns.)

In June 2016, on Bacon Street, the century-old brick and concrete storm drainpipes and combination former sewer pipes are being replaced. Unfortunately, the devastating 2016 El Niño winter storm flooded the area before the new pipes were in. Ironically, exactly a century before, in 1916, the biggest storm of the century also badly flooded Ocean Beach. These storm pipes were also put in too late. (Author's collection.)

In 1926, Joseph Mehling sits in his stroller in the garden under a Queen Ann avocado tree next to his home at 4930 Muir Avenue. This is one of four of the family's avocado trees.

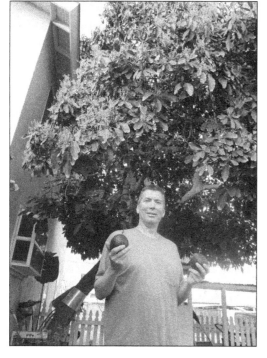

Michael Mehling holds avocados in 2013 at 4930 Muir Avenue. Amazingly, the same avocado tree in the 1926 photograph at the top of the page, which Michael's father Joseph sat under as a baby, still produces fruit. (Author's collection.)

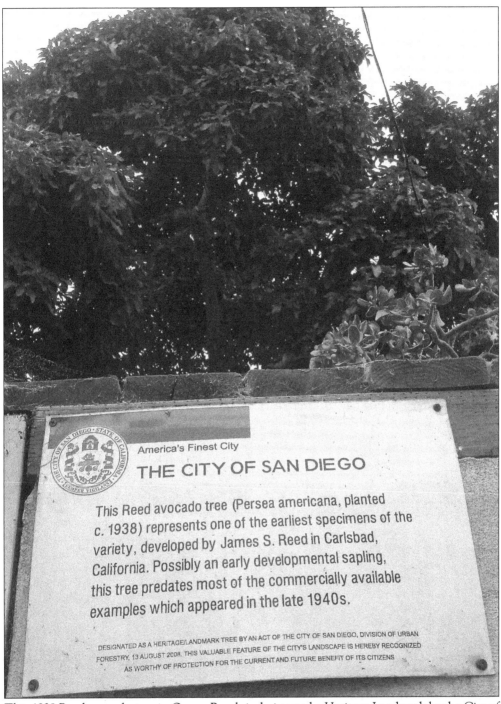

This 1938 Reed avocado tree in Ocean Beach is designated a Heritage Landmark by the City of San Diego, Division of Urban Forestry. It represents one of the earliest specimens of this variety, developed by James S. Reed. In the early part of the 1900s, Point Loma's theosophists also planted many varieties of avocado trees locally. (Author's collection.)

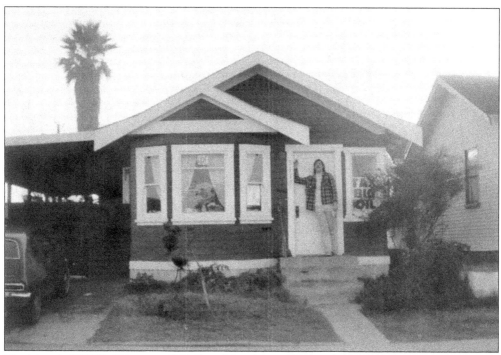

The historic 1915 Red House at 5113 Cape May Avenue has a colorful history. From the 1960s to the 1980s, it was the community center for many of OB's movements. Resident Tom Kozdn, at the door, was one of dozens of activists who organized or were instrumental in many local community institutions, which included the Ocean Beach Community School, the Ocean Beach Community Plan Board and Precise Plan, Ocean Beach Food Co-op, and more. (Courtesy Robert Burns.)

The Ocean Beach Community Free School started in several houses, including the Red House, seen here in the early 1970s. It was patterned after Summer Hill School. The alternative school offered traditional classes, creative subjects, and community learning experiences.

OBceans' battle cry of "Save the Red House" was heard in the 1970s. A developer was going to replace the Red House with condos, tenants were served eviction notices, and residents were under FBI surveillance. Lengthy lawsuits over the status of the house were conducted. In the end, the Ocean Beach community prevailed by doing what they do best: putting out a flyer and having a party. The event brought awareness, raised money for lawsuits, and resulted in historical designation. The Red House was saved. (Courtesy Robert Burns.)

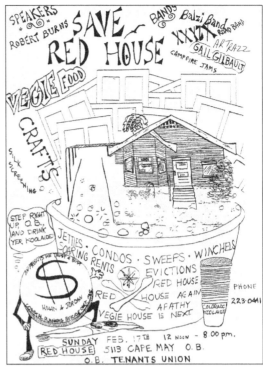

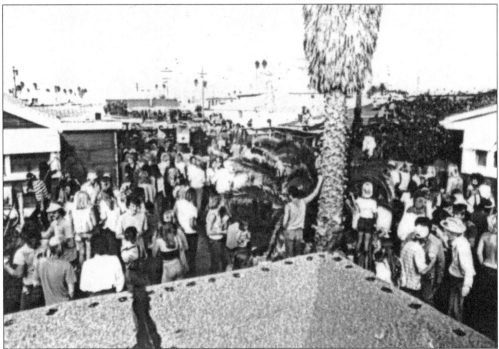

Party fundraisers helped save the Red House—along with lawsuits, petitions, and historical designation. Tom and Jane Gawronski bought the Red House in 1992, restored it, and repainted it red. They had a 100-year anniversary celebration of the Red House, which many OBceans who were part of its colorful history attended. (Courtesy Robert Burns.)

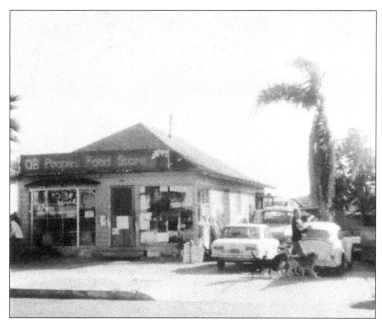

Ocean Beach People's Food Co-op opened on August 19, 1972, at 4859 Voltaire Street. Later, the store moved a block east to a larger building. Outgrowing that building, the owners leveled it and bought an adjacent property for a new two-story green market, renaming it Ocean Beach People's Organic Food Market. In 2017, more than 13,000 individuals own the co-op.

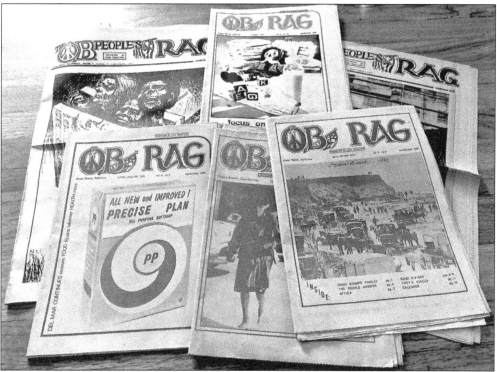

The *OB Rag*, published from 1970 to 1976, was an alternative grassroots newspaper for Ocean Beach that took on the establishment while giving voice to the burgeoning counterculture. The *OB Rag's* first publisher, editor, and writer, Frank Gormlie; volunteers; and activist staff fueled the community organizing moment in Ocean Beach. The *OB Rag* was revived in 2007, as a progressive blog and website that also brought back past articles from the 1970s paper version and added more current history to the topics.

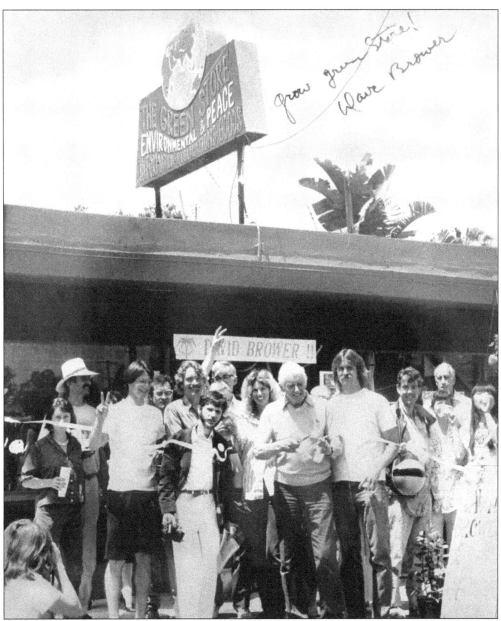

The Green Store's history and activism in Ocean Beach and San Diego was started on Earth Day, April 22, 1989, by cofounders Colleen Dietzel and Kip Krueger (standing in center) at a ribbon-cutting ceremony at their Voltaire Street location with famed environmentalist David Brower (between them). Working with groups such as the Ocean Beach Greens, Rainforest Action Network, Greenpeace, the Save O.B. Coalition, and Ocean Beach Grassroots Organization, among others, they embarked on a journey to try and save Ocean Beach and the world. Historically, the Green Store (renamed Ocean Beach Green Center) led the way as an eco-center working for the environment, peace, and social justice. (Courtesy the Green Center.)

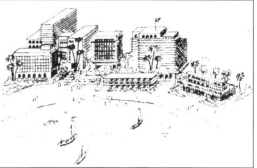

The third classification, hotel (high rise) visitor commercial, is proposed for the area generally bounded by Abbott, Long Branch and West Point Loma. The topography, view considerations, access and proximity to the ocean makes this an ideal location for high rise hotel and apartment development.

Local discourse exploded when a group of outside developers in 1968 came into Ocean Beach to build a yacht basin and surround it with high-rise buildings (plans pictured here). It would have destroyed the surf and the long sandy beach and displaced residents.

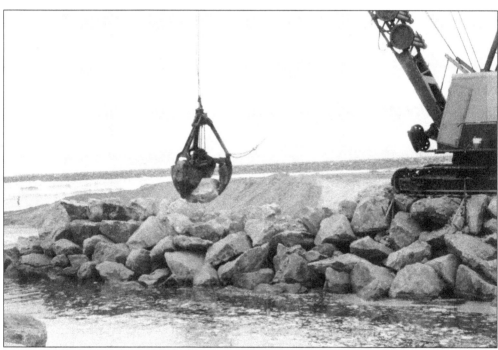

Cranes started building jetties for the yacht basin, but Ocean Beach residents came out in force revolting against the project by tipping over cranes, lifting rocks back onto the sand at night, creating stickers in opposition, forming the first community elected planning board in the state of California, and helping pass the public voter initiatives for the Coastal Act and Proposition D's 30-foot coastal height limit law. These actions and others saved the beach and help preserve Ocean Beach's character. A small jetty is left as a reminder to locals of the past battles.

The city bought Famosa Slough for conservation in 1990, after a successful activist campaign was launched in the 1970s and 1980s to save and restore the slough. Famosa Slough's history runs from being an ice-age coastal canyon to a part of the estuary of the San Diego River, a dump for construction rubble, a planned construction site, a city-owned urban wildlife preserve, and a hot spot for bird watching and conducting nature studies. (Courtesy Decker family.)

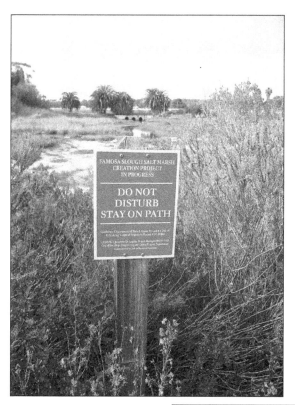

Part of Ocean Beach's Community Plan boundary is the channel that runs from the San Diego River under Interstate 8 to West Point Loma Avenue. Pipes then take the water to the Famosa Slough wetland preserve that sits in the Peninsula Community Plan area. In the early 1900s, the main Ocean Beach rail connection ran through this marshy area to Old Town and other parts of San Diego. (Author's collection.)

Some of the most beloved residences of Ocean Beach are osprey families that have lived here for generations. Stephen Rowell, a locally renowned Ocean Beach photographer, has been tracking ospreys for decades and keeps an amazing photographic log of their activities by making daily visits to the nests on the lights at Robb Field and along the San Diego River.

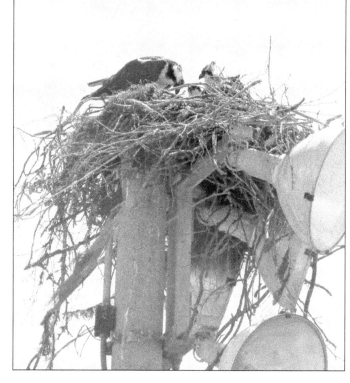

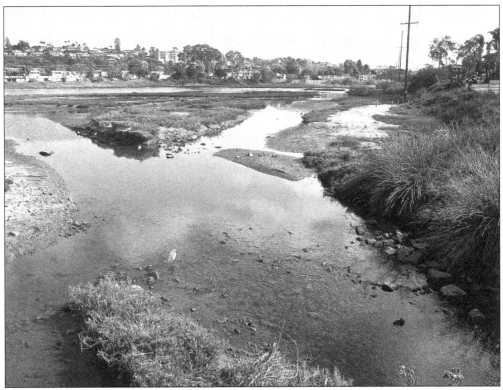

San Diego's Famosa Slough is a part of the city's Multiple Habitats Protection Area for the protection of at-risk, threatened, and endangered species, including endangered Ridgway's rails and California least terns. The Friends of Famosa Slough partner with the city to help manage and improve its value for wildlife and for visitors. (Author's collection.)

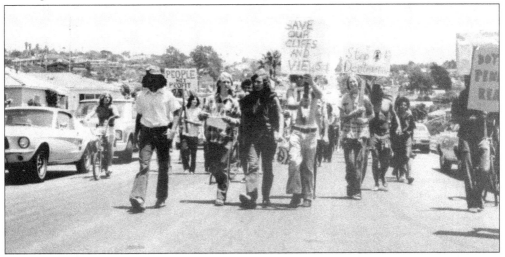

This image was captured during the OBceans' 1973 protest to stop the building of high-rises on the edge of the cliffs and expensive seawalls for the purpose of saving cliffside homes. The walls were built, but most fell apart and were costly to replace. Boulders placed at the foot of the cliffs destroyed most of Ocean Beach's sandy coves. Half a century later, with the onset of global warming, the California Coastal Commission is more in agreement with the OBceans' viewpoints.

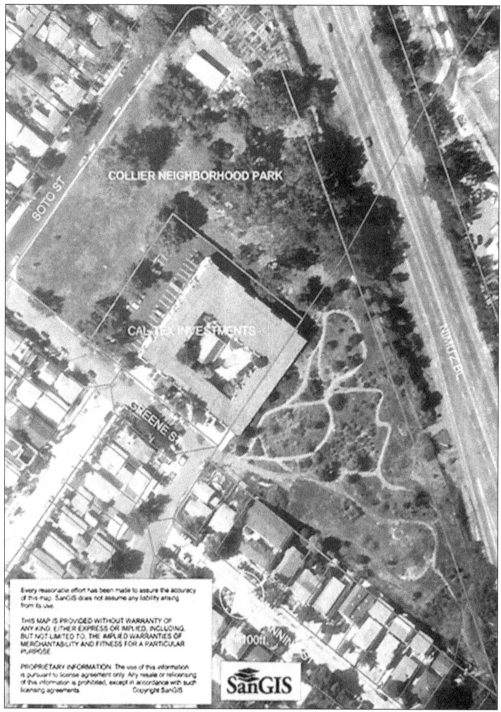

One of the most celebrated historical gifts to the peninsula came in 1909, when D.C. Collier had a dream of a park for the future children of his beloved community. One parcel was a 60-acre tract on pueblo lot 206 as promised parkland, upon which Collier promised to plant thousands of trees locally without cost to the city. He would also connect a road to the two main boulevards.

The D.C. Collier deal for pueblo land to become parks was followed by decades of turbulence that led to the loss of some of the protected parkland. Sizable parkland was saved due to Ocean Beach activists protesting, as seen in this sign, "Your town council is working for a park / Keep cool." Additional support came from the Point Loma Garden Club, People's Food Co-op, and community garden supporters, who all joined together to help establish the parks that included a native garden and a community garden. (Courtesy Stephen Rowell.)

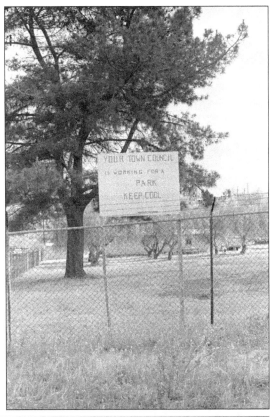

The park designation came in 1972, over a half century after Collier's park plan. The final parks on the property include Collier Park, the Point Loma Native Garden, the Ocean Beach Community Garden, and Cleator Park (ball fields.) Other parts of the property are no longer parkland. These became apartments (former site of the Salvation Army's Door of Hope, a home fore unwed mothers), a church, and a school.

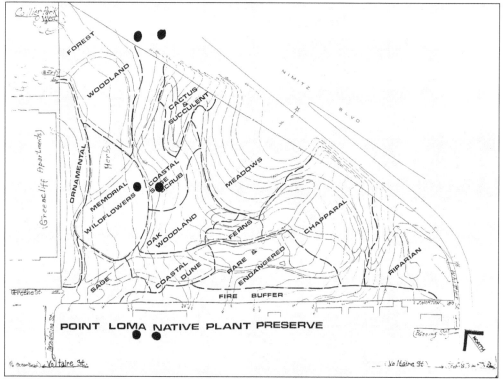

3986 La Cresta Drive
San Diego, CA 92107
September 26, 1972

City Manager, Kimball Moore
202 C Street
San Diego, California 92101

Dear Mr. Moore:

Thank you and your able and considerate staff for recommending designation of Collier Park West—seven acres at Soto and Greene Streets—for park purposes.

Since the City Council officially designated the above park site on September 21, 1972, citizens from the Point Loma-Ocean Beach area will be formulating plans for development of Collier Park West for a neighborhood park.

Many organizations and individuals participated in the Park and Recreation Board—Western Area Committee—presentation, favoring designation or dedication of this park site—as recorded in the minutes of the July 11, 1972 meeting which also noted letters or position papers—21 altogether. Many other letters have been directed to the Mayor and City Council and will be on file in the City Clerk's office. Petitions have also been filed, containing 1700 signatures, mostly local—500 or more were obtained within one block to one mile of Collier Park West, requesting designation or dedication for park use.

Point Loma Garden Club has been the coordinating group for the preservation of Collier Park West, this year, and we shall continue our support. However, others will soon become more actively involved. Representatives from the Community will be contacting the Park and Recreation Department or others on your staff. You will find them most cooperative and appreciative of whatever help the City Administration can give toward planning and implementing the necessary development of Collier Park West.

It is hoped that this partially-wooded park site can be designed and completed as naturally as is feasible or reasonable at minimal expense. Ocean Beach Kiwanis Club and Point Loma Garden Club have already pledged $100.00 each toward development of Collier Park West. We have been told of other donations which will be coming in after plans become more stabilized.

You may be certain that most local citizens are grateful for your stand in favor of saving this naturally beautiful city-owned land in an area where there is a need for a neighborhood park.

Copy to: Maureen O'Connor,
Councilwoman, 2nd District

Sincerely,

Verlan B. King

Mrs. C. Douglas King
Civic Action Chairman

Enc. Letter To
Mayor and City Council

POINT LOMA GARDEN CLUB

Official designation and plans by review groups and individuals participating in efforts to establish Collier Park West were made on September 26, 1972. This letter is from the Point Loma Garden Club to the city manager.

Plans from 1970s for the Point Loma Native Plant Preserve on the east side of the Collier Park West parkland were due in great part to horticulturist John Noble, founder of Coastal Sage. Noble drew up plans, landscaped with other volunteers, and later gave horticultural tours of the native garden. (Courtesy Noble.)

The Ocean Beach Community Garden was the brainchild of People's Food Co-op and local health-food advocates. Now, a variety of residents have plots to grow their own food.

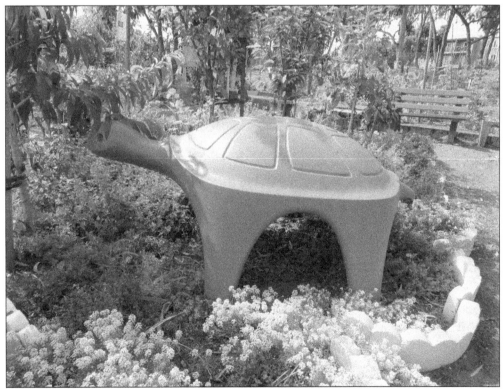

The blue turtle figure resides in the Ocean Beach Community Garden, but it was a piece of play equipment in the adjoining Collier Park before the playground was dismantled. The apartments (seen in the upper right) were built on park-allocated property and where the Door of Hope had been. (Author's collection.)

People ask why Ocean Beach is a quaint beach town versus "Miamization." It is due to OB's activist community and the 30-foot coastal height limit law voter-approved 1972 people's initiative that was upheld by the courts. The law was the brainchild of a dedicated activist group called VOTE (the flyer for which is seen here) with the foresight and drive to realize strong protections were needed to preserve views and coast from overdevelopment.

VOTE founder Mignon Scherer, a former Ocean Beach resident, and Alex Leondis, VOTE chair (center), along with other 30-foot coastal height limit pro-advocates, met for a 2007 press interview in Ocean Beach on Orchard Avenue. The building to the left and an unseen one to the right went over 30 feet high. The left building had been fast-tracked through the city approval process shortly before the law was in place. (Author's collection.)

Six

LOCAL COLOR

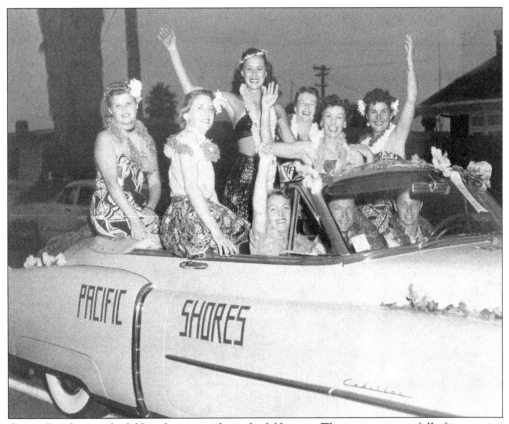

Ocean Beach is a colorful beach town with a colorful history. The community is full of interesting and passionate characters. Creative, adventurous, and fun-loving people gravitate toward and tend to thrive in this unique community. In this photograph, the Pacific (PAC) Shores bar crew of beauties rides in a 1949 Cadillac convertible driven by Lynn Church, with his wife, Evelyn Church, just behind him as they promote the popular Newport Avenue bar. The PAC Shores nostalgic bar is still a local favorite watering hole today.

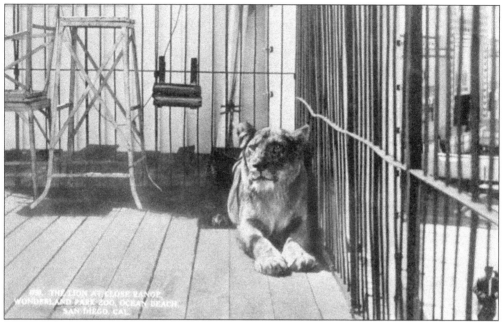

Ocean Beach residents are not always human. This lion was one of the Wonderland Amusement Park animals. Many Wonderland animals were moved to the 1915 Panama-California Exposition at Balboa Park. The animals were relocated to adjoining property to be on exhibit in the new San Diego Zoo in 1916.

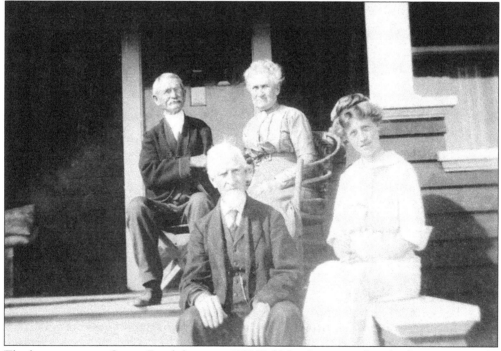

The large two-story Ocean Beach home at 4905 Del Mar Avenue took only about seven weeks to build in 1912. The Mulville family enjoyed their nice stoop and porch, where they could sit in the warm sun and visit with neighbors that passed by.

It is a dog's life in Ocean Beach in 1933. This pet pooch gets his doghouse moved on a wagon by barefooted Frank McElwee Jr. II. Frank's father holds the dog steady on the doghouse roof so pup can enjoy the view. (Courtesy McElwee/Peace family.)

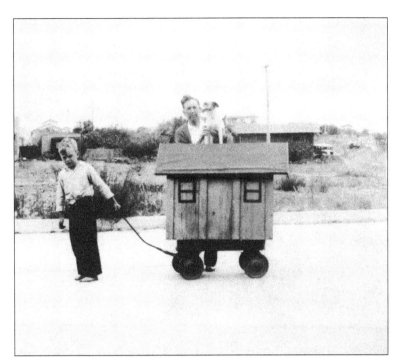

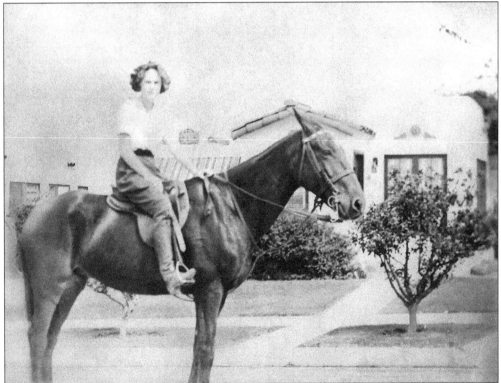

Marie Quist is pictured in front of her family's home on her horse King John, who was kept at stables on Catalina Boulevard. Maria's father Sevin Quist built the Spanish-style house on Cape May Avenue around 1929.

In 1944, Ocean Beach Women's Club (OBWC) members paint the fence of their new permanent clubhouse at 2160 Bacon Street, on property they received from Jean Rittenhouse. The building was formerly a church and a school bungalow and then was moved onto the OBWC's lot.

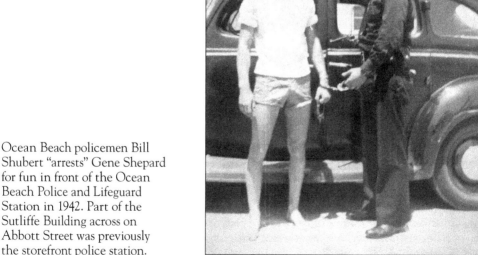

Ocean Beach policemen Bill Shubert "arrests" Gene Shepard for fun in front of the Ocean Beach Police and Lifeguard Station in 1942. Part of the Sutliffe Building across on Abbott Street was previously the storefront police station.

San Diego was known as the film location of Marilyn Monroe's *Some Like It Hot*. Lucky San Diegans had a real-life sensational women's music group. The trio, named the Ko Kottes (formerly the Mam'selles), had a violinist, bassist, and accordion player who toured the country and were located in Ocean Beach in the early 1940s. The trio played many local venues and symphonies.

The handwritten caption reads, "Almore Diet." These lovebirds owned a home over the hill in La Playa but rented a nearby beach cottage a couple of miles away in Ocean Beach for their romantic vacation.

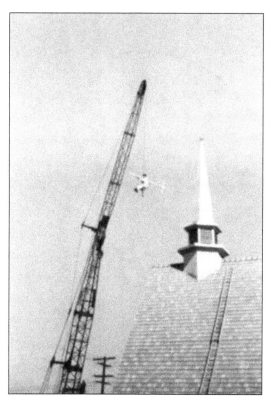

This construction worker hanging from a crane in 1960 is doing an amazing feat—but not a very safe cross installation on the steeple. The newly built Bethany Church at 2051 Sunset Cliffs Boulevard is on Ocean Beach's church row.

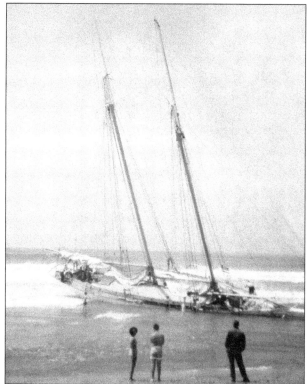

Sadly, this yacht sailed aground in Ocean Beach in the 1980s. Inexperienced sailors mistook the shallow flood control channel at the San Diego River mouth on the north edge of Dog Beach for the entrance to Mission Bay.

Great weather inspired much of Ocean Beach residents' outdoor social activities with friends in 1959. The Aikens had many backyard parties with friends, where they furnished the drinks, lawn chairs, and a dartboard.

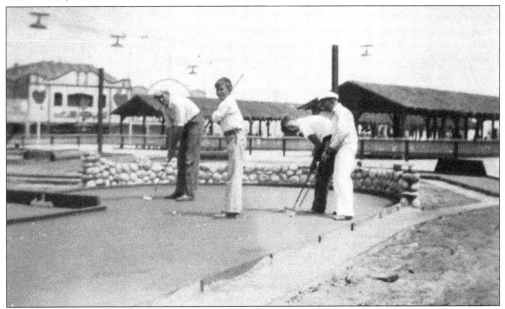

Guido H. Faber, his son Guido "Buddy" Faber, and friends enjoy playing miniature golf in Ocean Beach in 1930. The electric trolley lines run behind the miniature golf course.

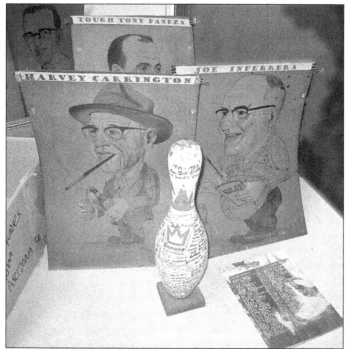

The Ocean Beach Bowl opened in 1946 next door to the Arizona Cafe bar, where a cartoonist drew caricatures of regular customers for the walls. A sepia patina from years of cigarette smoke exposure browned the sketches.

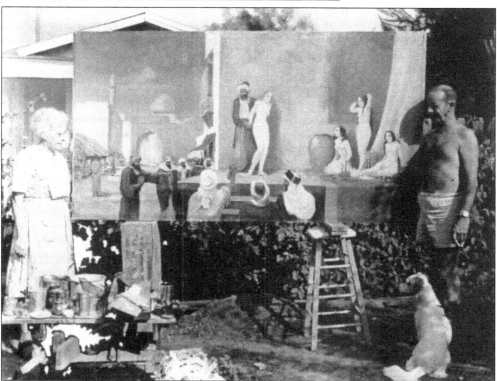

Gustafine Dorbaum, a potter, and Eugene L. Taylor, a painter and sculptor, are seen outside their home art studio at 4856 Del Monte Avenue in 1955. They also had an art studio in Spanish Village, Balboa Park.

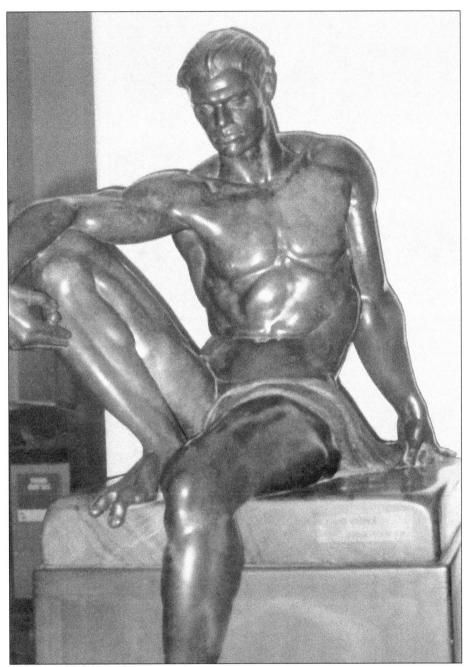

San Diego sculptor Donal Hord, considered one of America's greatest artists, left an impressive legacy and body of work in San Diego. In 1951, Hord taught life drawing classes at the Art Center (Museum of Contemporary Art San Diego) in La Jolla, where he sketched a handful of local surfers as models, then immortalized them using a mix of their various body parts for his famous *Young Bather* sculpture. These models included Ocean Beach residents 16-year-old Robert Gonzalez, who was used for arm muscles and abdominals; and Raymond "Skeeter" Malcolm, for various parts; and Pacific Beach's Dominic Moceri, for the nose. The SDHC used *Young Bather* on *The Sensual Sculpture of Donal Hord* reception invite for May 14, 2013. (Courtesy Robert Gonzalez.)

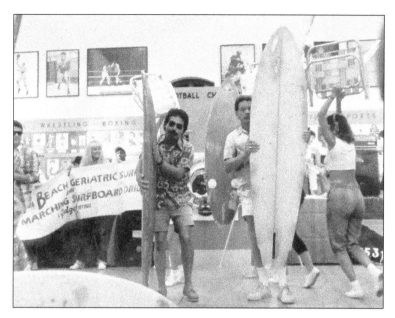

The Ocean Beach Geriatric Surf and Marching Band Surfing Drill Team and Gidget Patrol formed in 1984 and performed through 2012. They entertained and were inducted into the Hall of Champions at the 1987 exhibit *Surfing San Diego.* (Courtesy Williams collection.)

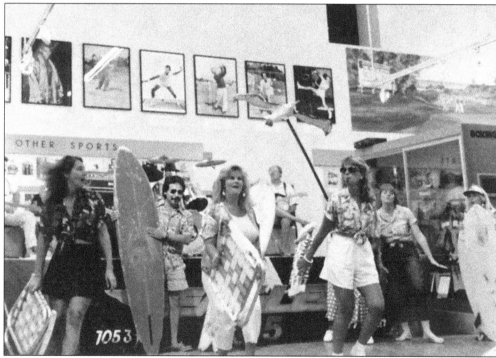

The Ocean Beach Geriatric Surf and Marching Band Surfing Drill Team and Gidget Patrol were launched nationally after winning the Grand Sweepstakes Trophy in the Pasadena Doo Dah Parade. That led to appearances in a Wendy's commercial, movies, and other television commercials. (Courtesy Williams collection.)

Ocean Beach cartoonist Mike Dormor loved surf culture. He created the surf character Hot Curl in 1963. Dormor built a large Hot Curl statue on the cliffs of Wind and Sea in La Jolla, where the character gained notoriety. *Hot Curl* was a popular cartoon strip in *Surfer* magazine, and there was also a Hot Curl toy figurine as well as a Hot Curl clothing line. (Courtesy Dormer family.)

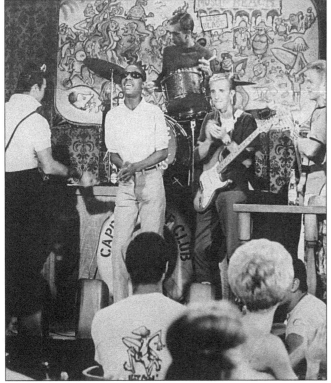

Mike Dormer's Hot Curl surf art (behind band) appears in the opening of the 1964 classic movie *Muscle Beach Party*, with music cameos by Stevie Wonder and Dick Dale and the Del-Tones. Dormer also took a group of local surfer guys and gals to Los Angeles, where they danced in swimsuits into the director's office and were immediately hired for the film. (Courtesy Dormer family.)

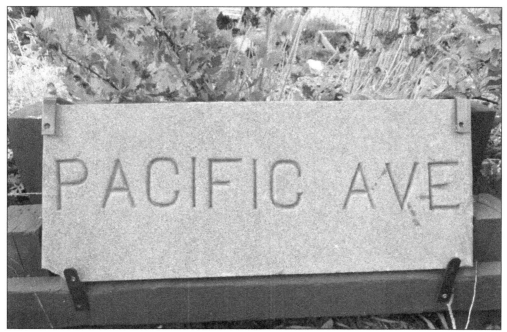

The Pacific Avenue piece of historic sidewalk nameplate was saved from demolition by a resident when the handicap curbs were put in. Many residents ask: "Why was the 1887 Pacific Avenue name changed to Coronado Avenue?" "Why was La Jolla Avenue renamed Orchard Avenue?" City staff does not have records of why these street names were changed in the 1920s.

The new Masonic Temple Point Loma Lodge 620 on Sunset Cliffs Boulevard was built in 1950. Here, the men take a break from their labor to enjoy refreshments provided by the wives.

The Ocean Beach Woman's Club members liked to have fun at their annual hat contest fundraiser in May. They designed colorful blossomy hats from live flowers, like this one. Proud 1960 winner Mae Clark wears her colorful flowery pyramid hat with a smile.

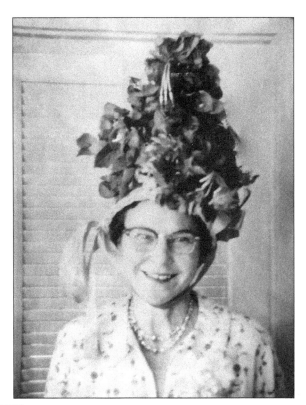

In 1925, First Master Franklin Althouse Plank helped establish the Point Loma (Peninsula) Masonic Temple at a building at 5019 Newport Avenue in Ocean Beach. The new Masonic Point Loma Temple Lodge 620 cornerstone-laying ceremony, held by Claude H. Morrison, PGM, took place in June 16, 1951, at 1711 Sunset Cliffs Boulevard. The members convened in the new temple January 31, 1952.

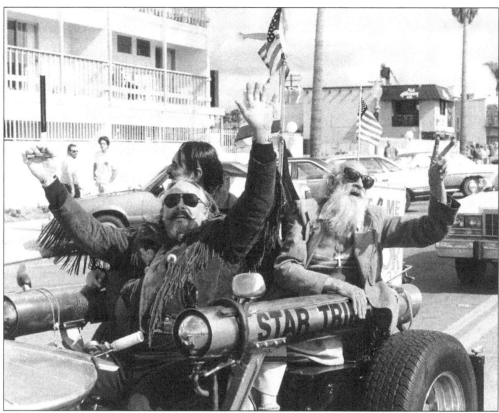

Stephen Rowell photographed an iconic moment in 1992 at the second to last Kite Day Parade on Newport Avenue. Ocean Beach character Lock David Crane cruises by on his *Star Trek* trike, his homage to the starship *Enterprise*, with passengers John Hood and the OB "Spaceman" (Clint Cary), who give the peace sign to the crowd. (Courtesy Stephen Rowell.)

The Life Story of One of the World's Great Painters

The O.B. Spaceman Strikes Again!

This work was created to make people talk and make them laugh, and what's wrong with that?

By Linda Wilson

The OB Spaceman was a cosmic backlight artist. He claimed to be in contact with beings from outer space that authorized him to distribute numbered spaceship boarding passes to people to be shuttled to the alien's planet. Several publications and a play have been written about Spaceman.

Seven

THE CHILDREN OF OCEAN BEACH

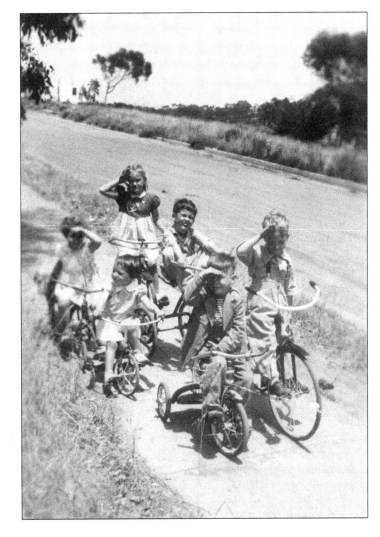

Back in the day, Ocean Beach biker gangs were "pretty tame." Charles "Chuck" Massey (on the right) roamed and explored the local streets and sidewalks with his gang. Many of the streets were still dirt. Generations of children who lived in Ocean Beach remember it as truly paradise—a giant playground with beaches, the plunge, open lots, fishing, and local entertainment.

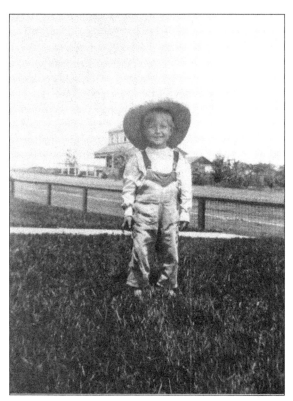

In this 1913 photograph, four-year-old Clifford Ausad stands in his signature hat and overalls in his grassy front yard on Cable Street, where he loves to play. He would frequently visit the Mulville's large home, seen behind him.

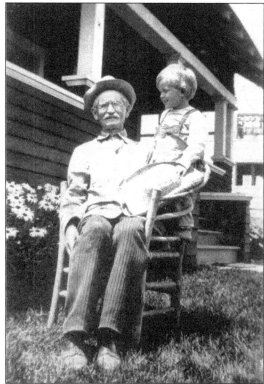

Martin Mulville enjoys time with Clifford Ausad in a rocking chair in the front yard of his home at 4905 Del Mar Avenue. Mulville describes Clifford as "the neighbor boy who was here most of the time."

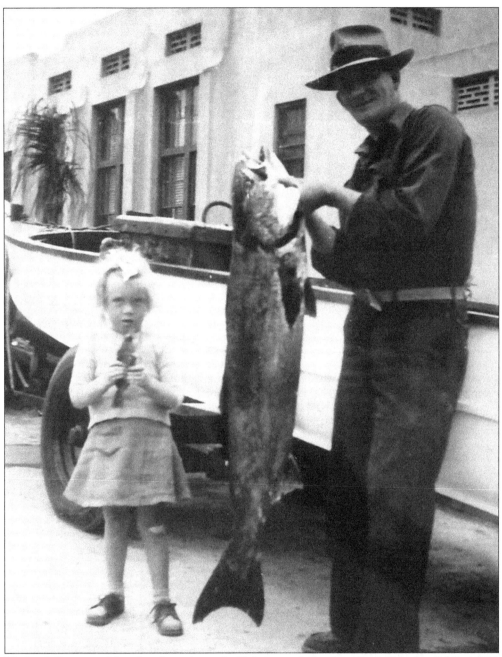

Harland Carter and his daughter showed off their catch for this "little fish, big fish" c. 1950 photograph. Local fishing from boats or the Ocean Beach Pier was popular for the novices and professional fishermen.

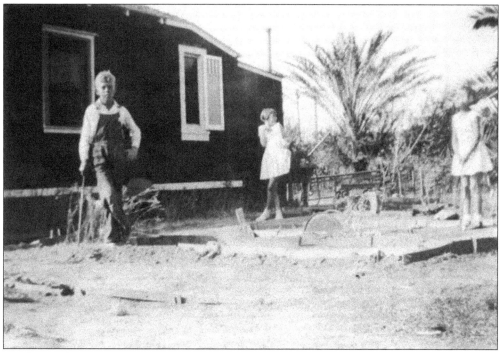

As a kid, Bud Faber made a miniature golf course in his backyard. Bud and his wife, Ruth, pioneered the midsummer "Days of Fun" with carnival games, food, and entertainment in the Newport Avenue beach parking lot in 1944. The Fabers were founders of the Easter parade, with kids on bicycles, and were involved with Kite Day and the Christmas parade.

Playful young girls entertain themselves by wearing goofy glasses and eating ice cream. This crowd seems to be waiting around for something. Local events were common during this period. (Courtesy Mehling family.)

Four girls in their uniforms and hats pose for their picture on the front of electric trolley in the 1920s. They stand on the No. 26 Ocean Beach trolley.

Ocean Beach was full of open space in the early 1900s. Frank McElwee Jr. II and his mother, Mary, hold onto their basket as they survey the landscape for the best place to picnic. Back then, there were lots of spots to choose from.

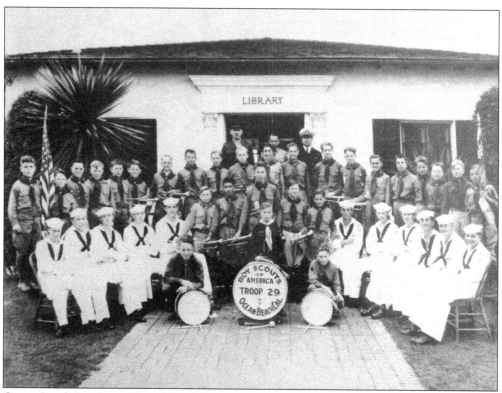

Ocean Beach Boy Scout Troop 29 and Scoutmaster Tallie M. Welch, US Navy, pose at the Ocean Beach Library in 1933. Architect Robert W. Snyder designed the 1928 library, built at a total cost of $18,697 for the lot, building, and furniture.

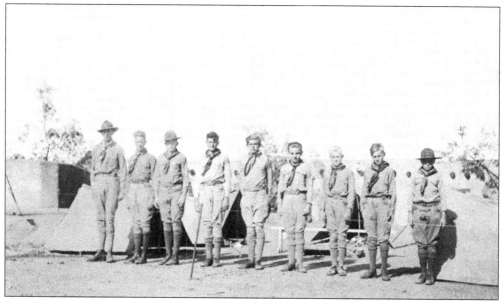

Ocean Beach Boy Scouts at attention in 1934 are, from left to right, Scout leader ?, Geoffrey Rothero, Noel Firiley, Wesley Carter, Jack Kelly, Buddy Faber, Jess F. McBeth, Jeffery Hall, and Russell Hageamler. (Courtesy Faber family.)

Chuck Massey was a lucky kid to get his photograph taken on a pony in 1939. An industrious fellow made his living going to resident's homes and photographing their children on his pony.

These three children stand under the flagpole in front of Union Ice Truck at the Camp Holiday Auto Court. The little cottages were next to the Silver Spray Hotel and Apartments up on the bluff that overlooked the beach.

Marie Sevin (Quist) sits in dressy clothes by her family's sparsely decorated Christmas tree with homemade decorations and plain white lights, typical in the 1930s. Many folks, including Marie's parents, were facing hard times. Marie's Christmas gifts were a couple oranges and a new slip. (Courtesy Laurie Gerber.)

Tony DeGarcia and his father stand in front of the apartments on Lotus Avenue in the northern section of Ocean Beach. The building they are in front of had previously been the Wonderland office building, but was then moved and converted to apartments. As an adult, Tony bought and refurbished the historically significant structure after it had been condemned in the 1990s.

The Ocean Beach Junior Woman's Club sponsored the December 17, 1953, Christmas party at their clubhouse. Members' children visited with Santa, who emptied his pockets full of goodies. Members gave a Christmas basket to a local needy family.

Ocean Beach's popular annual children's Derby Day Race in 1947 started up the hill at Froude Street and went down Newport Avenue. Some of the Soap Box Derby cars had local sponsors and were very well built, as seen in the photograph.

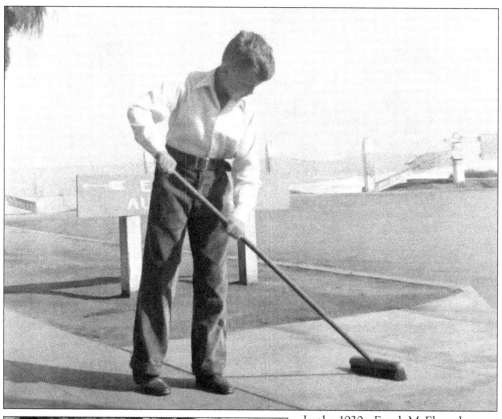

In the 1930s, Frank McElwee Jr. II sweeps the driveway entrance to his parent's Camp Holiday Auto Court at the end of Niagara Avenue overlooking the ocean. The short chain-link fence in the background became the entrance to the later-built concrete Ocean Beach Pier in 1966.

Charles Massey (far right) and friends enjoy a neighbor's backyard pond in the early 1940s. Massey, a history buff who enjoys doing historical reenactments, has very fond memories of his childhood and friends he played with in Ocean Beach.

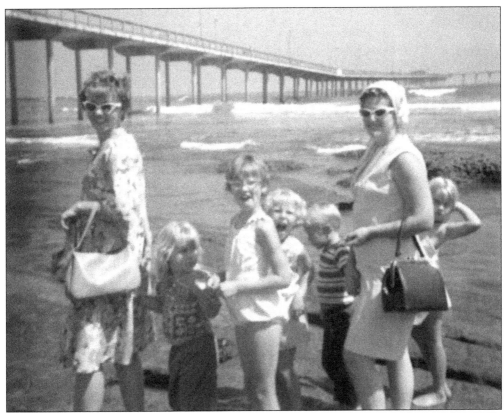

Stylish young mothers Jonnie Wilson (left) and Bonnie Reddington sport their coolest 1960s sunglasses as they trek along the beach to the Ocean Beach Pier in 1967 with their kids, from left to right, Erin Wilson, Linda Wilson, Joanne Reddington, Richard Reddington, and Kerry Wilson.

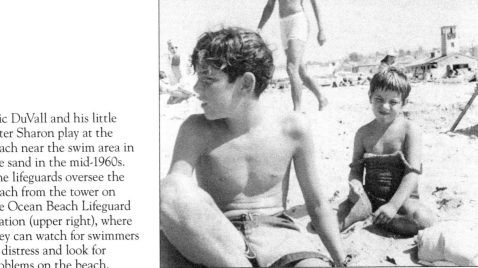

Eric DuVall and his little sister Sharon play at the beach near the swim area in the sand in the mid-1960s. The lifeguards oversee the beach from the tower on the Ocean Beach Lifeguard Station (upper right), where they can watch for swimmers in distress and look for problems on the beach.

Visit us at
arcadiapublishing.com

CPSIA information can be obtained
at www.ICGtesting.com
Printed in the USA
LVHW062249160519
618185LV00022B/563/P